CW00382449

IMAGES
of London

HIGHGATE
AND
MUSWELL HILL

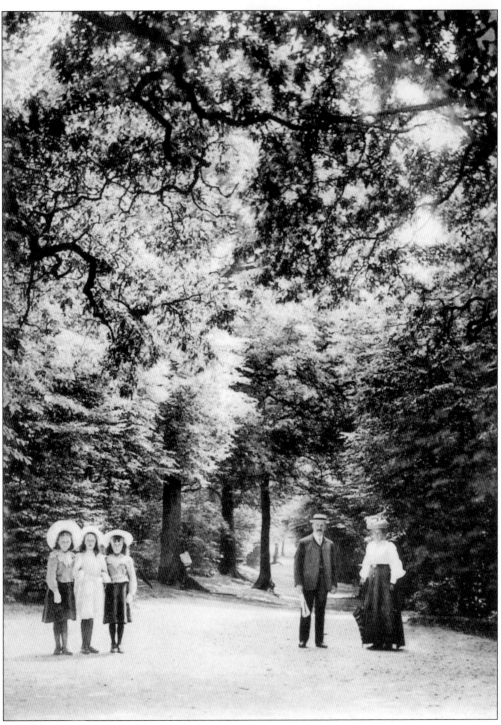

Highgate Woods.

IMAGES
of London

HIGHGATE
AND
MUSWELL HILL

Compiled by
Joan Schwitzer and Ken Gay

TEMPUS

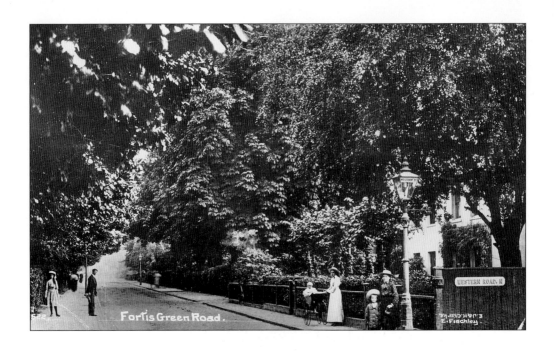

Fortis Green Road.

First published 1995, reprinted 1997, 2001, 2003

Tempus Publishing Limited
The Mill, Brimscombe Port,
Stroud, Gloucestershire, GL5 2QG

© Joan Schwitzer and Ken Gay, 1995

The right of Joan Schwitzer and Ken Gay to be identified as the
Authors of this work has been asserted in accordance with the
Copyrights, Designs and Patents Act 1988.

All rights reserved. No part of this book may be reprinted
or reproduced or utilised in any form or by any electronic,
mechanical or other means, now known or hereafter invented,
including photocopying and recording, or in any information
storage or retrieval system, without the permission in writing
from the Publishers.

British Library Cataloguing in Publication Data.
A catalogue record for this book is available from the British Library.

ISBN 0 7524 0119 X

Typesetting and origination by Tempus Publishing Limited
Printed in Great Britain by Midway Colour Print, Wiltshire

Contents

Acknowledgements

This book can be said to complete the coverage of the chain of hills known as the Northern Heights initiated by Christina Gee in her *Hampstead and Highgate in Old Photographs* (High Hill Press, 1974). But the authors are conscious of gaps. They have tried to avoid pictures that have appeared in other publications, and in the 1980s Highgate was well illustrated in the work of John Richardson. Muswell Hill, on the other hand, is comparatively unknown territory. They have extended the scope to the war years and after, and have included a greater proportion of personal photographs than is usual, and they hope to have made some new insights possible.

They have been helped by private collectors who have generously loaned their photographs and postcards: Peter Barber, Margaret Burn, David Cook, Oliver Cox, Emma Dickinson, Hugh Garnsworthy, Hilda Johnston, Alfred Leigh, Mary Rogers, Joy Tomkins, Linda Warden, and Dick Whetstone.

They are also grateful to the Vicar of All Saints' Church, Highgate, and to the Hornsey Historical Society for lending items from their archives.

The authors would like to thank the archivists of several London collections for permission to reproduce pictures; details are given at the end of the book. They wish to pay particular tribute to Mrs Gwynnedd Gosling, Archivist of the Highgate Institution, for help with research. The authors have used a few of their own photographs, taken in the course of a long residence in the area.

March 1995

Introduction

Highgate and Muswell Hill were once part of the Forest of Middlesex. In the beginning was the wood. Tracks along the higher ground were made by man where the views were better and the going was drier. The Romans came and left evidence of their stay in the form of coins found near Southwood Lane and Muswell Hill Road, and in the remains of pottery kilns in Highgate Woods. The extent and duration of their settlement is unknown, but a fort may well have been established on the Highgate plateau, with its steep slope on two sides and radiating ridgeways.

After the Romans left, the hilly nature of the area seems to have held back the clearance of the land for agriculture. Woodland and its wild creatures flourished and became, as elsewhere, a feudal domain, in this case a manor of the Bishop of London. His hunting park embraced a large part of modern Highgate and Finchley. The southern boundary was contiguous with Hampstead Lane and Hornsey Lane, a demarcation which was also used between parishes and is perpetuated today in the boundaries of Haringey, Camden, and Islington.

Highgate by the thirteenth century was becoming a place, being the high point where the Hampstead to Crouch End ridgeway met the roads from London northwards coming up Dartmouth Park Hill or Highgate West Hill. It was a virtual crossroads. At the very summit a chantry was set up and a settlement developed. Farmers leased land from the Bishop and an area of common was established. By the fourteenth century travellers, instead of having to proceed to Muswell Hill to join the main road to the north, were allowed to use a new road through the deer park, entering or leaving by the tollgate which gave Highgate its name. Later an inn, the Gate House, was built alongside the tollgate, and other hostelries opened round Highgate Green. Their customers were to include many drovers bringing animals to the London markets.

Around this Highgate plateau, people with business at Court or in the City acquired land and built themselves country houses. Aristocrats and merchants, Lord Mayors among them, were attracted not only by good communications with London, but by the clear air and spectacular views. By Tudor times, Highgate straddled the newer main road to the north, via Holloway and Highgate Hill, and it became one of the principal

staging posts for coaches. In a religious age, a pre-requisite of residence, a place of worship, was provided by the chapel of Sir Roger Cholmeley's Grammar School, founded in 1565 on the site of the medieval chantry, dissolved with the monasteries by Henry VIII.

After the upheaval of the Civil War, with great changes in land ownership, Highgate developed as a country town with terraces of houses and shops for professional men and tradespeople. Urban amenities included chapels of different denominations and numerous schools. Writers, academics, politicians, actors, and business people made their homes there. Many eighteenth-century buildings and a few earlier ones remain in Highgate.

Muswell Hill, not far from Highgate, is situated at the eastern end of the Northern Heights, which fall away dramatically here. Its commanding views over the Thames and Lee valleys have made it an attractive place to live over the centuries, providing a rural retreat graced by woods and hills for those who could establish estates. It was to escape urbanisation until the very end of the nineteenth century.

The earliest recorded reference to Muswell Hill dates back to the mid-twelfth century when the Bishop of London, who was the Lord of the Manor of Hornsey, granted some 65 acres to an order of nuns recently established in Clerkenwell. Situated on the east side of Colney Hatch Lane, this land contained a natural spring or well. John Norden, the Tudor historian, described how a king of the Scots was cured of a disease by taking the waters of this well, and in medieval times this well was to become a place of pilgrimage. The nuns built a chapel near it, 'bearing the name of our Ladie of Muswell', and Muswell Hill became the name of the district in place of an earlier name. The chapel was to disappear with the dissolution of religious houses by Henry VIII, but administration of the land was to remain with Clerkenwell parish until 1900, and was known as 'Clerkenwell Detached'.

Distinguished residents in the seventeenth century included Sir Julius Caesar, Master of the Rolls to James I, and in the eighteenth century Sir Topham Beauclerk, an illegitimate descendant of Charles II who entertained Dr Samuel Johnson and other notables at The Grove. Nearby were Bath House, The Elms and The Limes, large houses which clustered near the pond at the top of the hill.

London's nineteenth-century expansion led to many Victorian villas in their own grounds being established, marked by a profusion of mature trees and bounded by chestnut paling. North Bank is a surviving example. But most were to disappear when, in 1896, the vacant The Limes and the adjacent Fortis House estate were purchased by James Edmondson of Highbury, giving him 30 acres of flat land in the heart of the village.

Edmondson created a perimeter of shopping parades and laid out Queens and Princes Avenues. He went on to purchase Hillfield, The Elms, Wellfield and North Lodge, and to create a new suburb. Commodious terraced houses attracted middle-class residents. Another developer, W.J. Collins, simultaneously built over the Fortismere and Firs estates, and elsewhere. Between them Edmondson and Collins created within a short period of time a homogeneous and unique suburb. Its shops and well-built houses, and its topographical position, continue to attract residents, and Muswell Hill maintains its reputation of being a good place to live.

One

Highgate: The Woods
and the Ridgeways

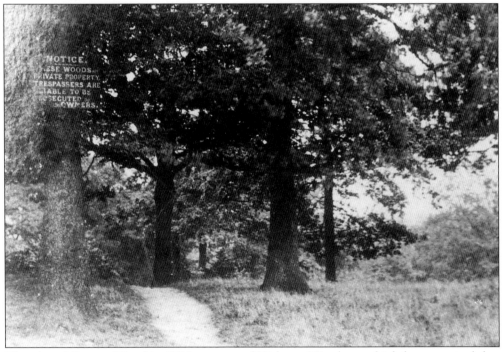

Churchyard Bottom Wood in 1884 was part of Highgate Woods on which leases expired that year. The landlords were the Ecclesiastical Commissioners, in succession to the Bishops of London. They discouraged visitors, as the notice shows, and had plans for re-development. But the prospect of streets of houses met with determined opposition, and the Commissioners eventually sold out to Hornsey Council. The wood was opened to the public in 1898 as Queen's Wood.

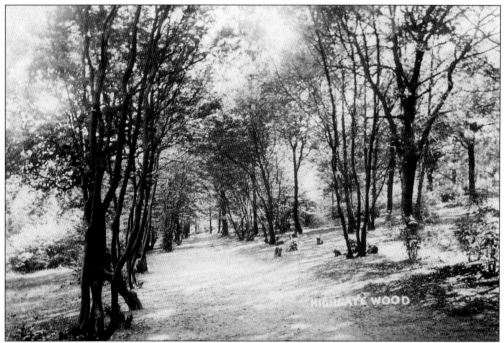

Highgate Wood, *c.* 1900, shows the effect of coppicing. Hunting had been abandoned by Stuart times and the woodland was leased to individual tenants. They would cut down young trees to ground level, causing multiple trunks to form, leaving some to grow to full height. Every few years different parts of the woods ('falls') received this treatment in rotation. A supply of stakes, posts and brushwood as well as large timber was thus assured.

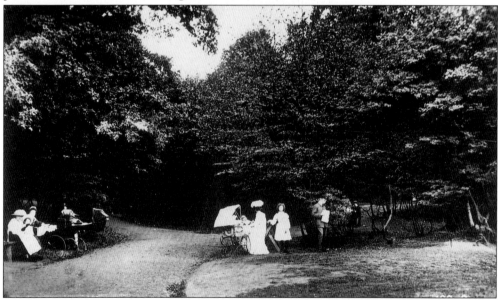

Highgate Wood in Edwardian times was a well-established local amenity. It had been handed over to the care of the City of London in 1885 after an effective campaign against residential development led by H.R. Williams, Chairman of the Hornsey Local Board. In the 1880s the wood had been Highgate's only public open space.

10

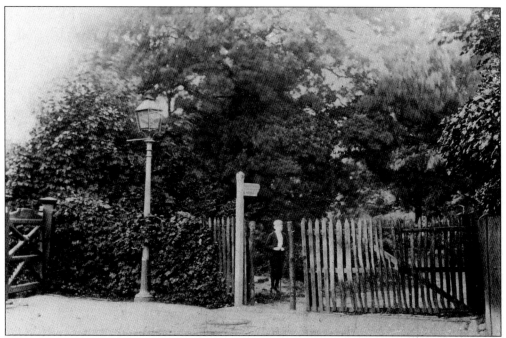

Wood Lane ended here in 1884, at the entrance to Churchyard Bottom Wood. When the wood was sold to the local authority, a condition of purchase was that the footpath had to be replaced by a road. So in 1900 Wood Lane was linked to Crouch End by Queens Wood Road and Wood Vale, where there were no houses until the 1930s.

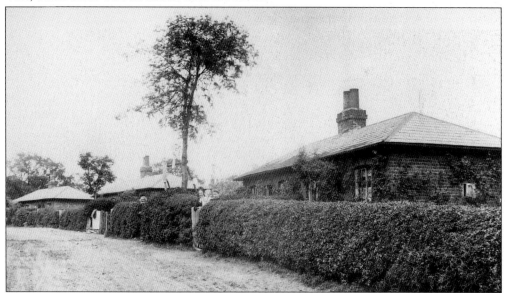

Waste Land Cottages in Muswell Hill Road were built c. 1830 as Parish almshouses. Permission to use this particular strip of 'waste' land between Churchyard Bottom and the road had been granted by the Lord of the Manor some years before the Hornsey Enclosure Act of 1813. Hornsey, like many other places, was then 'enclosed', and common land divided into lots and sold, in theory to improve agriculture. The cottages were demolished in 1896 to make way for terraced houses.

Queen's Woods, Highgate

In Queen's Wood, *c.* 1905, the lodge near Muswell Hill Road had been built, for the head keeper and his family. One of the daughters, Liza Chivers, has described her idyllic childhood in her book *Memories of Highgate*. The lodge had a Refreshment Room catering for Sunday School outings and picnic parties, as well as being a family home.

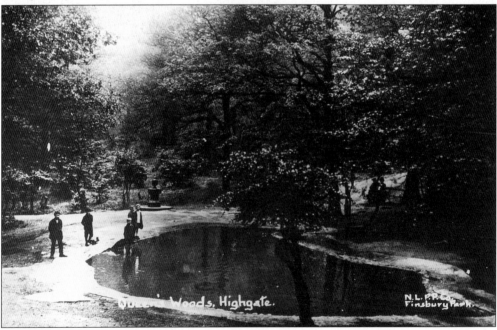

Queen's Woods, Highgate.

N.L.P.P.Co.
Finsbury Park.

The large pond in Queen's Wood was considered 'an attractive spot' on a hot summer's day by Liza Chivers, 'surrounded by trees with Rabbit Hill rising steeply towards Queen's Wood Road and the darting swooping dragon-flies with their beautiful iridescent wings flying over the water.' In 1935 it was replaced by a concrete paddling pool and pavilion.

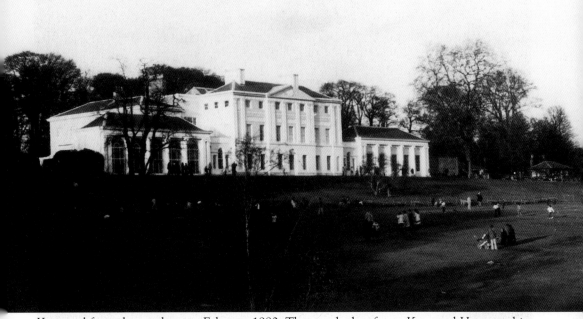

Kenwood from the south-west, February 1980. The woods that frame Kenwood House and its parkland and lakes are partly remnants of the original forest which continued on the other side of Hampstead Lane until just before the First World War. The woodland is commemorated in the name of one of the spacious residential streets built at that time, Bishopswood Road.

The Kenwood estate can be traced back to the thirteenth century but there was no house until the King's printer acquired the property in 1616. Kenwood as it is today was created by Robert Adam, the architect employed by William Murray, later the first Lord Mansfield, who bought the estate in 1754 when he became Attorney-General. Adam added a storey to the existing house and balanced the orangery wing on the west side by his famous library on the east. Later Mansfields tried to sell the estate for building lots, but Kenwood was saved, largely by Sir Arthur Crosfield and his Kenwood Preservation Council. The last private owner, the first Earl of Iveagh of the Guinness family, left the whole property for public enjoyment when he died in 1927: the parkland, the house, and his collection of paintings.

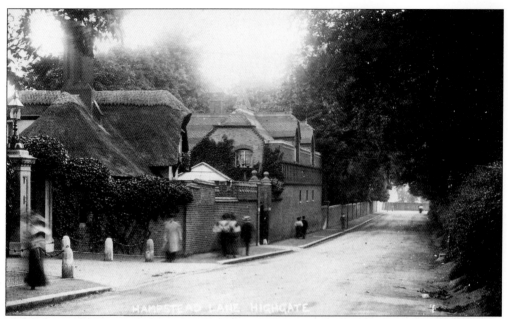

The entrance to Caenwood Towers, Hampstead Lane, *c.* 1905. Most of the south side of the lane has long been monopolised by the wealthy. A succession of secluded mansions has been built and the same three that existed in 1905 – Beechwood, Kenwood, and Caenwood Towers – exist today. Like its neighbours, Caenwood Towers had a lodge next to the main gateway. Later the entrance was moved further along, nearer the house.

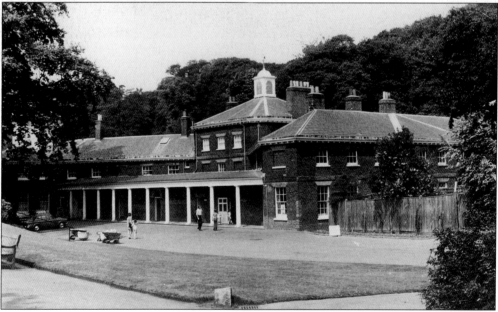

Kenwood 'Coach House', *c.* 1980. Built by the second Earl Mansfield from designs by his architect George Saunders, this service complex originally contained a laundry and brewery besides accommodation for the servants. Its size and dignity reflect the importance of a great eighteenth-century country estate. Lord Mansfield's domain included hundreds of acres of farms and woodland leased from the Bishop as well as his own pleasure grounds.

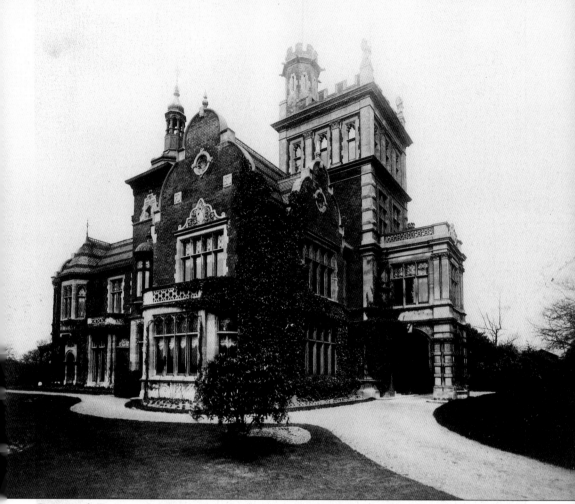

Caenwood Towers, c. 1883, was a Victorian businessman's dream house. Designed by E. Salomans and J.P. Jones, it was built between 1870 and 1872 for Edward Brooke (1831–1892), a leading manufacturer of the new chemical dyes. The Brooke family lived in style, with a bailiff, six gardeners, two coachmen, a butler, and nine other domestic servants. Brooke was succeeded in 1884 by Francis Reckitt (1827–1917) of the starch company, and he in turn by other professional men. Sir Robert Waley-Cohen (1877–1952), Managing Director of Shell Trading Company, was the last private owner, occupying the house between the Wars. He lived far more modestly than the first occupant, and on at least one occasion was mistaken for a gardener.

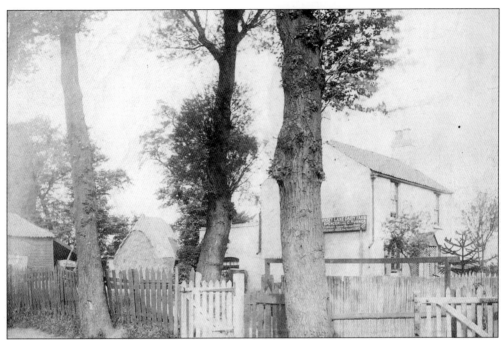

Spencer's Farm, on 5 April 1883, stands where the top of Stanhope Road is today. Its land amounted to over a hundred acres of fields and meadows. After houses were built along Hornsey Lane in the 1870s and '80s and side roads were constructed, Spencer's Farm (formerly Turner's as on the notice) moved their farmyard to a field by the railway bridge spanning Stanhope Road. In the 1890s children could still buy a glass of milk there on their way home from school.

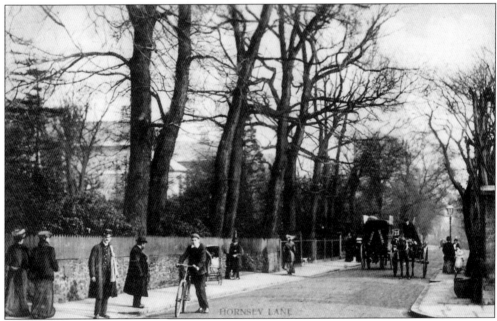

In Hornsey Lane, c. 1900, at the junction with Hazelville Road on the Islington side, a postman and delivery carts go about their business. The fields and the farm have gone and a row of large family houses links Highgate with Crouch End.

16

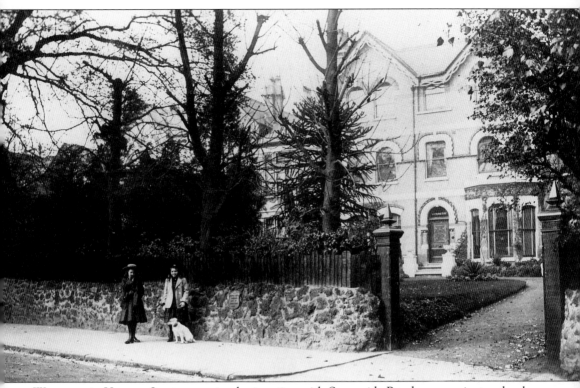

Wynnstay in Hornsey Lane, opposite the junction with Sunnyside Road, was a private school. These girls *c.* 1905 are probably pupils. Large houses frequently became schools, there being no shortage of customers. The new properties were specifically designed for prosperous middle-class parents requiring six, eight, or more bedrooms for their large families. Highgate had a traditional interest in education, partly due to geography. The town lay just beyond the Five-Mile radius from the City within which any professional activity by nonconformist preachers and schoolmasters had been forbidden after the Restoration in 1660. Highgate had become a happy hunting ground for the promoters of private schools and academies. Wynnstay was established by 1885 under the Misses Ann and Kate Cobely. Two other spinster ladies were in charge in the 1890s, and taking in both boarders and day girls. In 1905, the Heads were the Misses Blackhall.

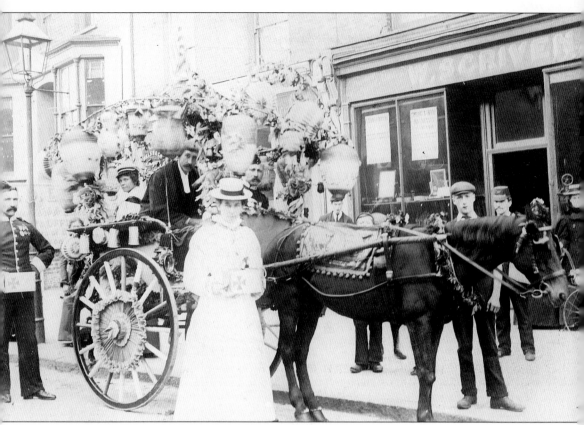

Part of Hornsey Carnival, near Hornsey Rise, in September 1901, with Mrs Scriven from the general shop in Hazelville Road setting out to collect money for the proposed Cottage Hospital in Park Road. Down the hill from Hornsey Lane, a community of artisans and tradespeople had developed, separated physically from Highgate by the row of big houses, but often drawn upon for domestic and other services. The same kind of relationship was soon to develop between the newly-built residences of Shepherd's Hill and the districts of Archway and Holloway.

Two
Hilltop Settlement

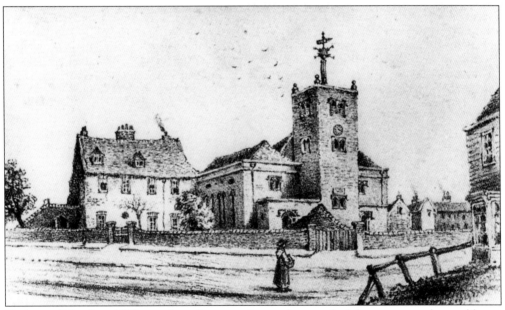

Highgate School, *c.* 1832, stood as always at the southern end of the two acres donated by an Elizabethan Bishop of London. North Road is to the left, the High Street to the right. Only the Master's house and the chapel feature in this Edwardian drawing by W. West based on an old print, the schoolrooms being behind them.

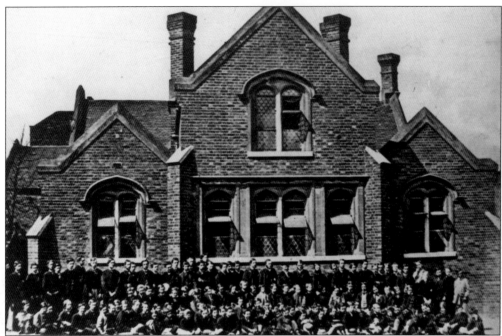

Highgate School in June 1865 was celebrating not only its tercentenary but its public school status under the formidable Revd Dyne. He had re-established the Grammar School after becoming Master when numbers had dwindled to less than twenty. The building was a legacy of 1819, when Cholmeley's foundation had become a virtual charity school for local boys and government Education Commissioners had demanded improved accommodation for them. The wings, containing a library and a further classroom, had been added later.

Highgate School's chapel, seen from South Grove c. 1900, was erected in 1867 to replace the old chapel, demolished in 1833. It was to be a memorial to George Crawley, a School Governor and benefactor. The buildings between South Grove and the school divide what was originally one open space, from the Grove across Pond Square to the Angel. The Reservoir, left, was installed by the New River Company, who first brought piped water to Highgate in 1857.

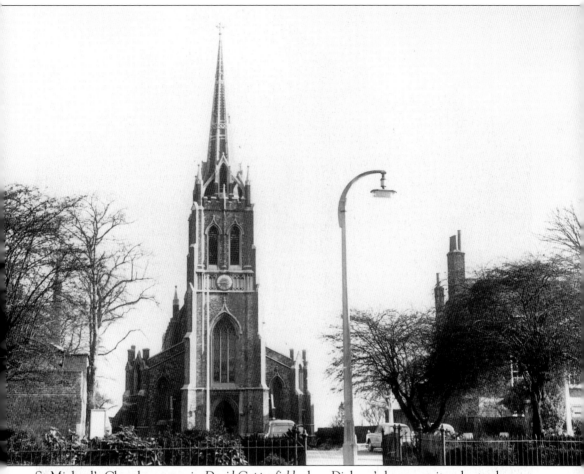

St Michael's Church appears in *David Copperfield* when Dickens's hero sees it as he trudges up the hill to visit the villain Steerforth. St Michael's was erected in 1832 on the site of Ashurst House, once the home of Sir William Ashurst (a Lord Mayor of London, who died in 1720) and later a boys' school. Before 1834, when St Michael's became an ecclesiastical parish, Highgate was technically a 'hamlet' with a 'chapel-of-ease' at the Cholmeley School for local residents who were otherwise expected to attend Sunday service several miles away, either in St Mary's Hornsey or in St Pancras church, depending in which parish they lived. The chapel had functioned almost as a parish church, with its own registers of birth, marriages, and deaths. Criticism of the School Governors, chaired by Lord Mansfield, for using school funds to maintain and enlarge the chapel had been allied to criticism of educational standards at the school, and resulted in acrimonious lawsuits in the 1820s. Highgate was split between opponents and supporters of the Governors. The final legal judgement in 1829 effectively sealed the fate of the old chapel and cleared the way for a new church that would be independent of the school. St Michael's was designed by Lewis Vulliamy (1791–1871) and built by Thomas Cubitt. Stained glass from the old chapel was used in the windows. It was consecrated on 8 November 1832. The first vicar, Revd Samuel Mence, continued to be Master of the Cholmeley School until 1838 when Dyne took over.

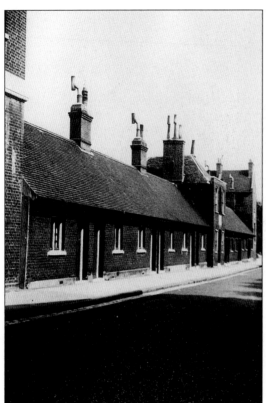

The almshouses in Southwood Lane were rebuilt by Sir Edward Pauncefort, a Cholmeley Governor, in 1722, for twelve poor widows. Originally, they had been built by Sir John Wollaston, the Parliamentarian who briefly held the Manor of Hornsey, for six inmates. The two-storey centre house was the charity school for 26 girls, maintained by the Governors. In 1950, the 1833 National School for boys and girls at the far end still survives but is soon to be demolished.

Highgate National and Industrial Schools in North Road (now St Michael's School), had started in Southwood Lane, largely as a community response to the Cholmeley law case. The Grammar School's status had been legally confirmed, necessitating qualified staff and hence the imposition of fees. Most of the existing pupils were thus excluded. In 1852 the National School moved into these buildings and a four-acres model farm. Here we see, in 1880, that the ground next to North Road is being cultivated.

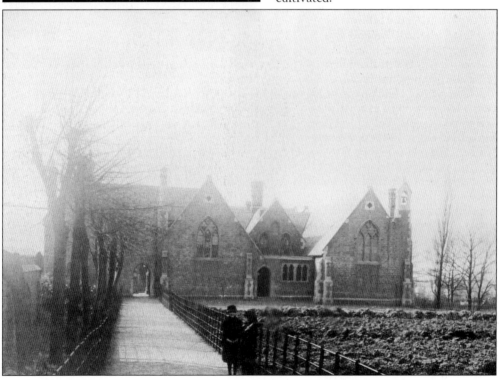

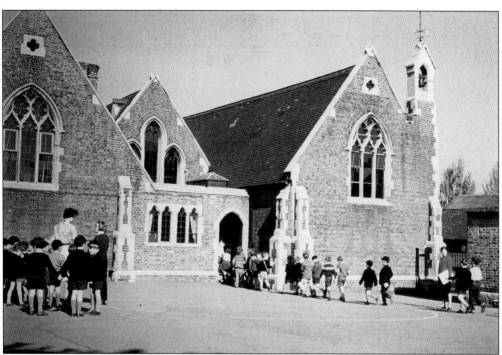

Going into morning school in 1964, the boys still wear caps and short trousers. Many internal alterations have also been made since then, and before. Originally the gabled structure with the belfry attached was the boys' department and its counterpart on the left the infants'. The girls had a separate building with a laundry and kitchen. in 1852 a curriculum had been planned that would encourage school attendance beyond the usual leaving age of ten.

Highgate's first infants' school in Castle Yard, seen in 1950, was later demolished, like the original National School for older pupils, for a housing development. The buildings seem to have first been used as a Methodist chapel but in 1839 the infants' school started there before moving into the purpose-built premises in North Road in 1852. Then it became the drill hall for the reconstituted Highgate batallion of the Volunteers and finally the British Legion's local headquarters.

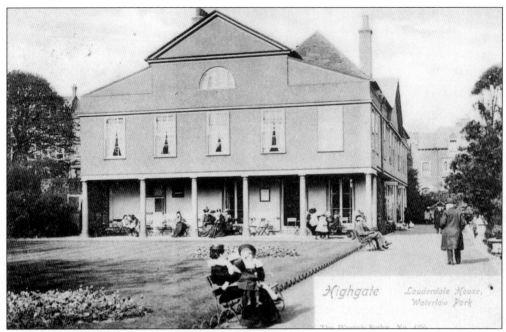

Lauderdale House on Highgate Hill is the earliest surviving mansion in Highgate. It was probably built for Sir Richard Martin, a goldsmith and Master of the Mint in 1580. The house disguises its timber frame under a classical facade added by later owners. From 1794 to 1837 it was a school, and in the 1870s a convalescent home. It passed into the public domain with the gift of Waterlow Park to the London County Council and is seen here *c.* 1907.

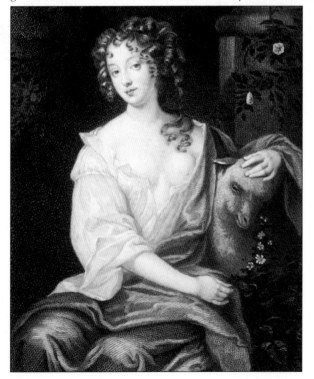

Nell Gwynn the actress was associated with Lauderdale House around 1670 when the Countess of Lauderdale was the owner. The Countess of Lauderdale was the wife of one of Charles II's friends who connived at the King's 'secret pleasures'. A recently discovered plan of the house shows a room near the long gallery labelled as 'The King's Chamber'. Was it by pure coincidence that two descendants of one of Charles's and Nellie's sons, the Duke of St Albans, lived in Highgate and in nearby Muswell Hill?

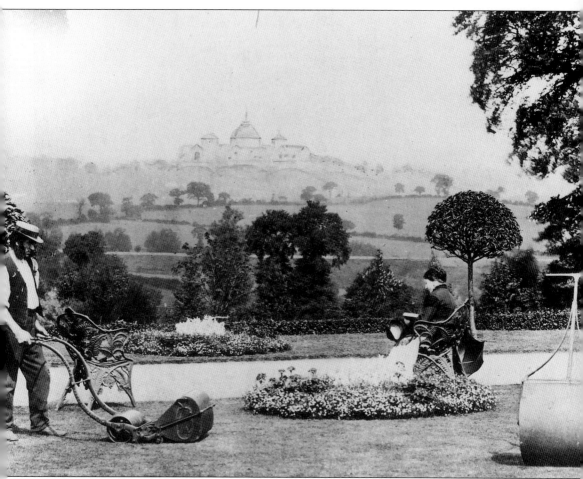

The view from Winchester Hall c. 1872 included the first Alexandra Palace, which can dimly be seen on the skyline. Winchester Hall stood next to Cromwell House on the corner of Hornsey Lane and was the home of William Jeakes, a prosperous London ironmonger. The chairs, lawnmower and roller may well have come from his shop. He was known socially as Colonel Jeakes from his position as Commandant of the Highgate Volunteers. Jeakes had commissioned a landscape gardener to improve the fifteen-acres estate. Huge hothouses for raising pineapples and grapes were erected, and an aviary, ornamental pool, and grotto built. Jeakes became President of the Highgate Horticultural Society and twice lent his grounds for the annual Show. He held office in several other voluntary groups and at the time of his death in 1874 he was Chairman of Hornsey Local Board.

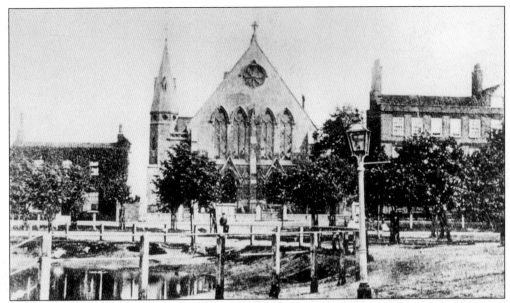

Pond Square *c.* 1860 is bordered on the south by the newly-erected Congregational church and Moreton House (right) where the poet Coleridge lived when he first came to Highgate, and by Ivy Cottage (left), a farmer's house, now gone. The pond was considered a health hazard and in 1863 was filled in. A plan to build on the space was, however, indignantly rejected by the majority of residents.

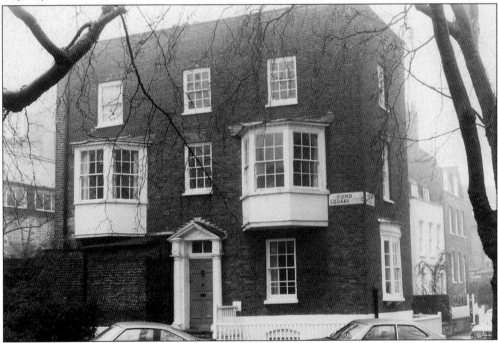

Rock House in Pond Square was built in 1777 but the name derives from a tenant of the 1840s, one John Rock. In the 1870s the house was used as the Highgate Dispensary of which Colonel Jeakes was Treasurer. The Dispensary had been founded in 1787 to provide free medicines for the poor of the town and the surrounding districts.

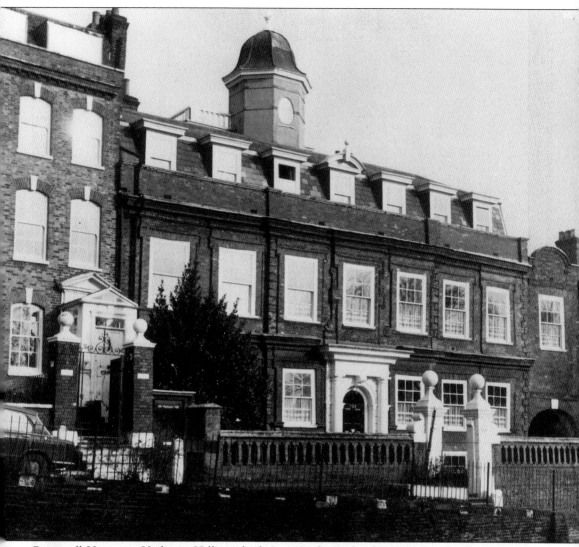

Cromwell House on Highgate Hill was built in 1638 for Richard Sprignell, a London trained bands captain, and has newel posts on the stairs carved in the shape of Jacobean soldiers. Originally this country house stood alone without close neighbours. The sash windows replaced the original mullions in the eighteenth century. The extension over the side archway was added by a later owner, Alvaro da Costa, c. 1700, and one room may have been used as a synagogue. Da Costa's initials over a fireplace were long misinterpreted as those of Oliver Cromwell, a theory given credence largely because of the Parliamentarians' dominance in Highgate during the Civil Wars. After a succession of private owners, Cromwell House was saved for posterity, like Lauderdale House, by institutional use. From 1830 it was a school, then after a serious fire in 1865 a convalescent home for Great Ormond Street Hospital, then a training school for missionaries before becoming an embassy.

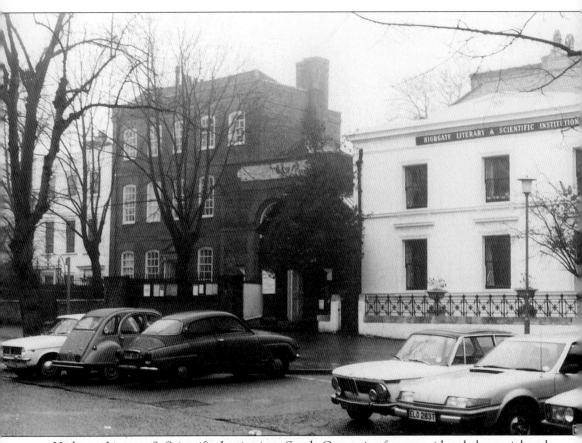

Highgate Literary & Scientific Institution, South Grove, is often considered the social and intellectual hub of Highgate. It was founded in 1839 by a local resident, Harry Chester, Assistant Secretary in the government department for education and a leading member of the Royal Society of Arts. His aim was to unite all classes in the pursuit of learning, and the Institution was only one of his social and educational initiatives. The infant institution bought its site from the Jewish school which was about to leave Church House (left), and made a lecture room out of the coach house and built a library, now the Reading Room (right). In 1879 the stable yard was roofed over to form the present lecture hall, the old lecture room became the library, and the entrance hall and porch were added. No. 10A South Grove, a separate meeting room between Church House and the Institution, was erected in 1848 for the new school at Church House run by Kilham Roberts, a friend of Dickens (who made the house a model for Steerforth's house in *David Copperfield*). Still owned by the Institution, 10A has been the headquarters of the Highgate Society since 1966, the year after its foundation. The Institution sold Church House in 1957 when finances were low, but now the flourishing 'Lit. & Sci.' is probably the only self-supporting institution among the few that survive out of hundreds founded in Victorian times.

Opposite: The knife grinder, plying his trade in Southwood Lane *c*. 1960, would once have been only one of many door-to-door services available to householders.

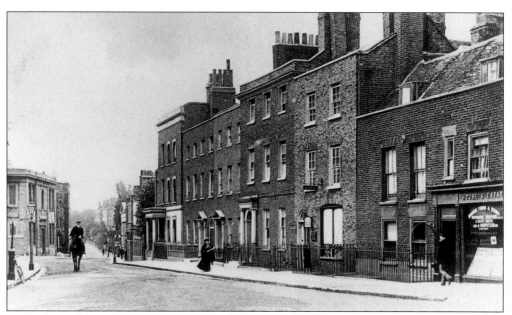

In Southwood Lane, *c.* 1910. The former 'British' School (left of the horse and rider) attached to the old Congregational church (superseded by the church built in 1859 in Pond Square) had been used by Highgate School for Science lessons since 1877. That was when Highgate Board School on North Hill was opened, satisfying nonconformist parents' desire for an undenominational, non-Anglican school for their children. In the 1920s Highgate School's Science block was built here, next to the Almshouses.

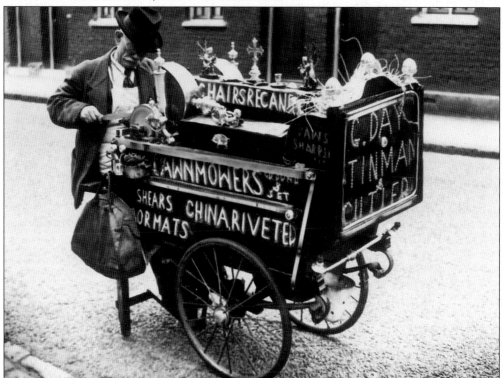

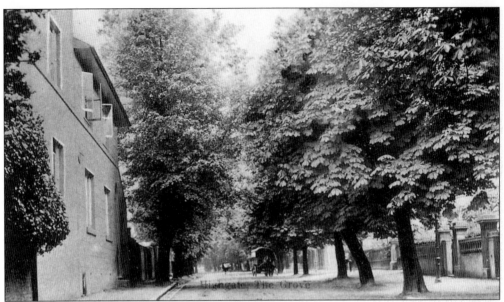

In the Grove *c.* 1905 the houses were almost hidden by the trees. With gardens overlooking parkland, and Kenwood beyond, the Grove is probably Highgate's most attractive road. Numbers 1 to 6 were built in the late seventeenth century on the garden of a Tudor mansion, Dorchester House. By Regency times the service road was known as Quality Walk. In the 1930s the author J.B. Priestley lived at Number 3, the home of Samuel Taylor Coleridge from 1824 until his death ten years later.

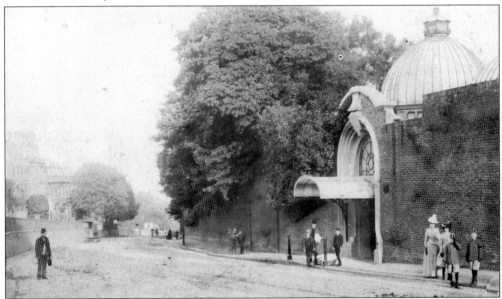

Fairseat on Highgate Hill, 1891, with the tramlines of the Cable Tram service outside. This was the home of Sir Sydney Waterlow (1822–1906), a rich wholesale stationer and printer for the Government. He was a Liberal Member of Parliament between 1868 and 1885 and the Lord Mayor of London in 1872–3. His numerous philanthropic activities included his Improved Industrial Dwellings Company, which provided blocks of flats for working people. Fairseat today is occupied by Channing Junior School.

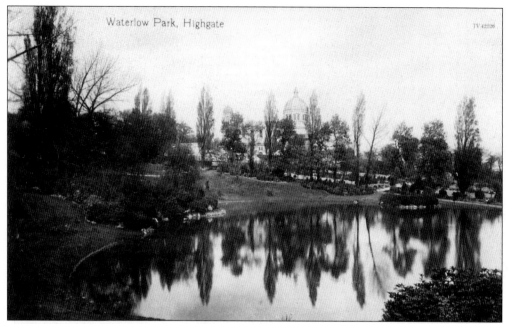

Waterlow Park, c. 1919. Sir Sydney Waterlow had presented it to the newly-formed London County Council in 1889. It had been part of his own private estate and when it was opened to the public in October 1891 he himself addressed the assembled crowd. It became immediately popular. On Whit Monday 1893, for instance, 50,000 people visited it. The middle lake displays a conventional tidiness which contrasts with the wilderness of today.

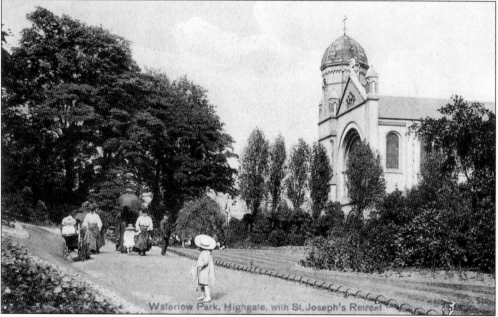

St Joseph's Church (seen from Waterlow Park c. 1910) had been opened in 1889. The smaller church it replaced had been built in 1858 and was the first Roman Catholic place of worship in Highgate for 300 years. Protestant opposition had been feared, and the purchase of land had been negotiated secretly.

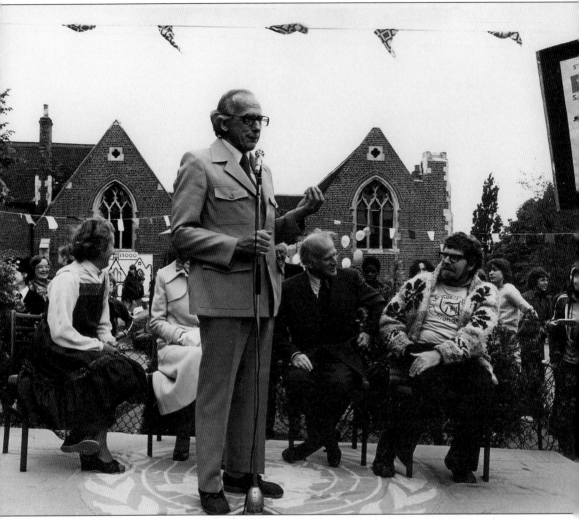

St Michael's School fête in June 1978 was one of the four-yearly fund-raising outdoor events that drew crowds in the 1970s thanks to the initiative and organising flair of Richard Grout (at the microphone). People on the platform include the Headmaster's wife, Pat Grout (left), Yehudi Menuhin, the violinist who lived at that time at Number 1 and 2 The Grove, and Rolf Harris, the entertainer. The afternoon's takings were for the repair of the school belfry (right), since accomplished.

Three
A 'healthfull' Place

Children in Parliament Hill Fields in 1958 would seem to verify Highgate's long-standing reputation as an ideal family place of residence. John Norden, the Elizabethan cartographer, called Highgate 'not so pleasant, as healthfull'.

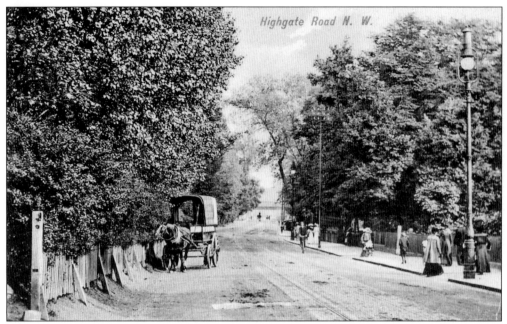

Highgate West Hill *c.* 1905, with leafy private estates on both sides, looks like a country lane. As a child John Betjeman lived in one of the two mid-Victorian terraces built on Highgate West Hill, 'Up the hill where stucco houses in Virginia creeper drown', and soon became conscious of his privileged position. He tells us he felt a 'childish wave of pity, seeing children carrying down Sheaves of drooping dandelions to the courts of Kentish Town'.

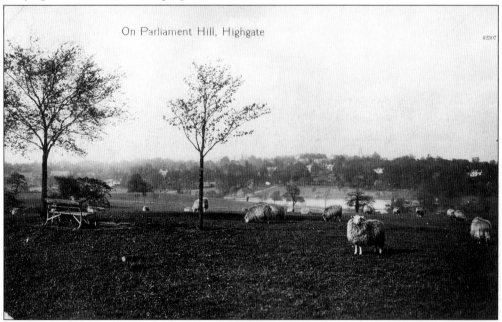

On Parliament Hill, Highgate

On Parliament Hill *c.* 1915 with the spire of St Michael's Church on the skyline, looking down on Highgate Ponds. These were in existence by 1600, having been dug out to trap natural spring water from a tributary of the River Fleet, for a new London reservoir. The sheep were a common sight on the Heath and in Kenwood until *c.* 1960.

34

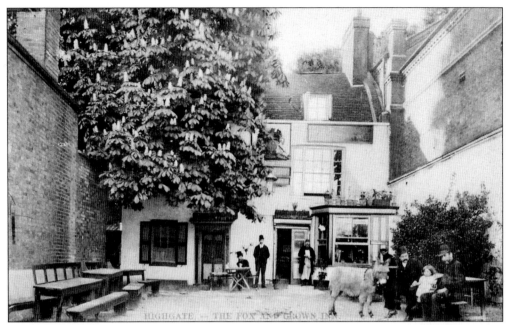

The Fox and Crown on Highgate West Hill c. 1895. The inn had catered for travellers toiling up the steepest part of the hill since at least 1704. It was demolished in 1898 but gained immortality from the plaque above the doorway with the royal coat of arms, now preserved in the Highgate Institution. The plaque records that in 1837 the young Queen Victoria's life was saved by the landlord, who stopped her horses bolting with her carriage.

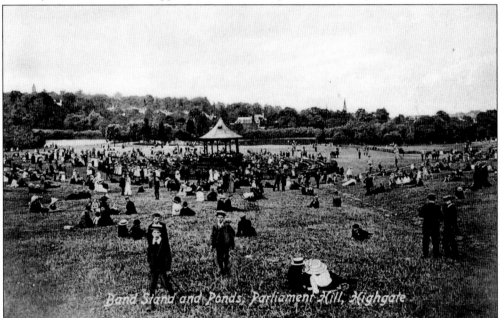

The bandstand near Parliament Hill c. 1910. This was a favourite spot on Bank Holidays with its brass band and the background of Highgate Ponds where one could watch the men swimming. There was no mixed bathing and ladies were allotted one day a week for the exclusive use of a pond.

Millfield Lane's rustic appearance c. 1905 was retained until the big estates that bordered it on the east side (right) were sold and redeveloped after the Second World War. It was the meeting place of Coleridge, Keats, and Hazlitt.

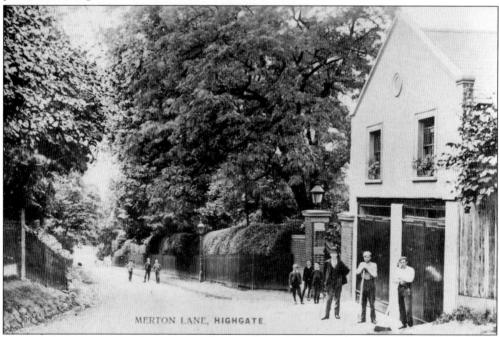

MERTON LANE, HIGHGATE

In Merton Lane c. 1905 is the coach-house of Merton Lodge. When the house was built in 1888 the lane had been widened to take carriages. In the 1820s it had been simply a right of way to Hampstead across Lord Southampton's Fitzroy Park estate, and a favourite walk of Coleridge's. Two other big houses filled the remaining frontage of the lane. Merton Lodge became Holly Court, an L.C.C. Open Air School in the 1920s and after the Second World War a Special School.

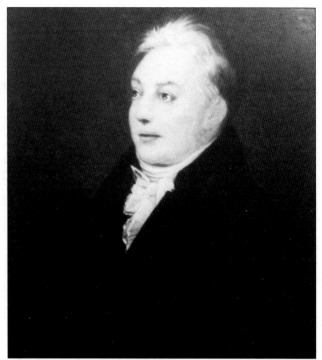

S.T. Coleridge (1772–1834), author of *The Ancient Mariner* and many other poems, became famous in his day as a philosopher. Born in the West Country and returning there after University, he came to Highgate in 1816 hoping to be cured of drug addiction. He lived in his doctor's house. Secret recourse to the local pharmacy, however, prevented a cure. He was known for his brilliant conversation. He died in the house in the Grove to which his hosts had moved in 1823.

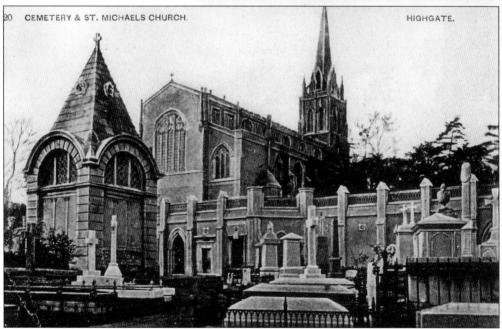

20 CEMETERY & ST. MICHAELS CHURCH. HIGHGATE.

Highgate Cemetery was founded in 1839 as one of seven cemeteries instituted by Parliament around that time to replace the over-full London churchyards. The joint stock company that was to run it bought land on the former Ashurst estate, and appointed an architect, Stephen Geary (1797–1854). At first resented by Highgate residents it became a source of pride, with its impressive tombs – seen here *c.* 1905 – and garden vistas. The romantic wilderness came only after the Second World War.

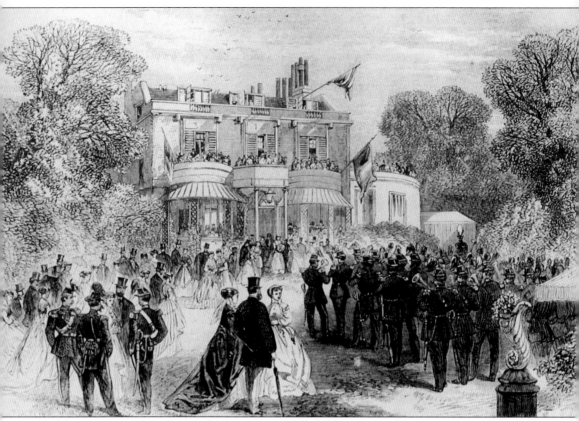

The reception of the Belgian Volunteers at Holly Lodge on 19 July 1867 was one of the events hosted by the immensely rich philanthropist Angela Burdett-Coutts (1814–1906). Being an educationalist, she had some staging erected in front of St Michael's church on this occasion so that the local school children could see the procession as it approached her house. Holly Lodge was built on land acquired from the Ashurst House estate. Angela inherited it from her step-grandmother, the Duchess of St Albans, who was the widow of the banker Thomas Coutts, Angela's grandfather. Fear of fortune hunters probably explains why she did not marry until 1881 when she was 67. Her husband, William Ashmead-Bartlett, was her secretary and just 30. Not long after their marriage, Angela and William hosted another great reception at Holly Lodge, for an international medical congress. William became MP for Westminster in 1885 and remained so until his death in 1921. Angela's usual place of residence was in Stratton Street, Piccadilly, but she spent part of the year at Holly Lodge. Her country home was the venue for the Highgate Flower Show on ten occasions between the 1860s and 1890s. Besides having an extensive formal garden, she also had a model farm. She kept several unusual animals, including llamas, and was a pioneer of animal welfare.

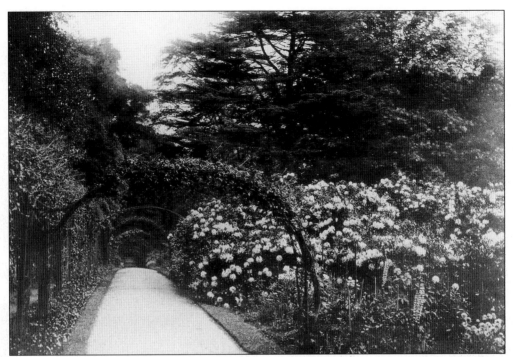

The rose bower walk was part of the famous garden at Holly Lodge, with its lavish herbacious borders and a background of cedars, beeches, and other forest trees. After Angela died, her widower tried to sell the estate but failed. He managed to sell the southern part for housing, his interest in conservation being largely confined to the Brookfield Horse Stud which he had started.

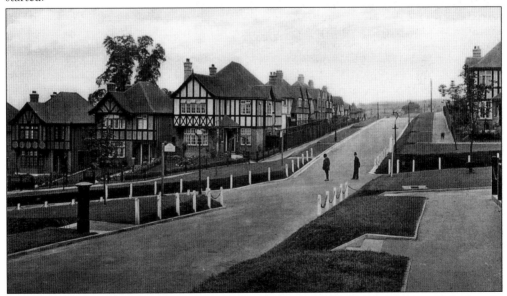

The Holly Lodge estate c. 1927, after Ashmead-Bartlett's death. The estate which Angela Burdett-Coutts had created was sold and Holly Lodge itself demolished. A small part of the garden remains to the south of Holly Lodge Gardens and also the carriage drive up from West Hill.

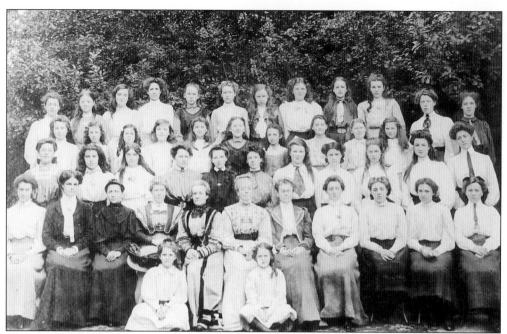

Earlham in Bishopswood Road was one of several local private schools for young ladies around 1900. Run by the Misses Rigg in a large house built in the 1870s on the edge of Highgate School's cricket field, it lasted from the 1890s till about 1918. The Mademoiselle who taught French is in the front row in dark clothes.

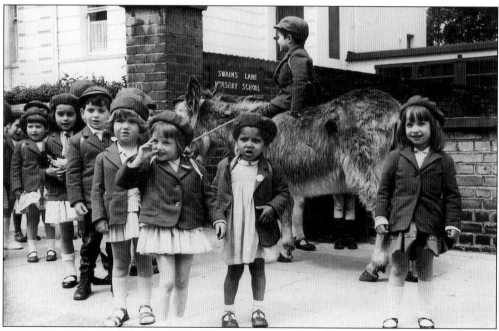

Swains Lane Nursery School *c*. 1960 which was founded in 1953 by Mrs Hilda Johnstone, the Head Teacher. The donkey was a pet of her rider's family and brought the boy to school each morning. For the last three years of its existence the school moved to St Albans Road where it remained until 1964.

40

Four

Roads North

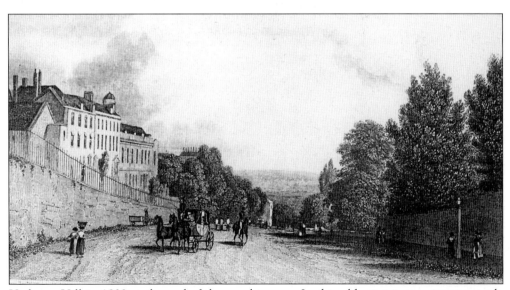

Highgate Hill in 1839 at the end of the coaching era. In this old print it was given a greatly exaggerated width by the artist. The Bank (left), where Cromwell House and its neighbours stand, protected pedestrians from the mess created by the passage of animals down the hill.

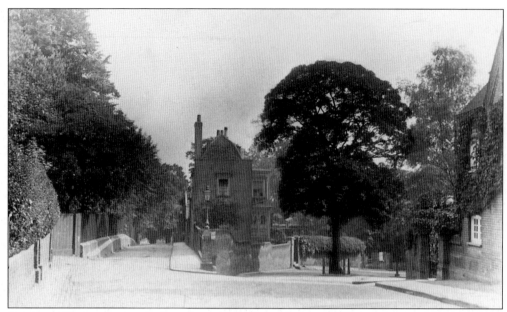

Southwood Lane, seen at the junction with Jacksons Lane *c.* 1907, ran due north between two old estates, that of Park House on the west and Southwood House on the east. The houses themselves were built in the eighteenth century, like Bank Point Cottage (centre). The building on the extreme right is part of Southwood Court, built *c.* 1880 and inhabited from 1922 by the proprietor of Odhams Press, who later took the title of Lord Southwood. It was demolished in 1965.

The top of Jacksons Lane in 1979 had changed little apart from the protective bollards since the previous century. Hillside, on the right, was the home of the man whose name stuck to the lane. 'Squire' Jackson, who died in 1826, is said to have habitually ridden down the lane and taken the bridlepath along Shepherds Hill to Hornsey.

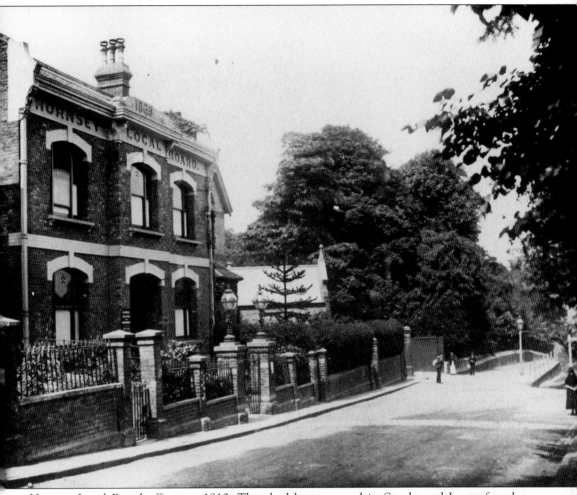

Hornsey Local Board offices, *c*. 1910. They had been erected in Southwood Lane after the Parish of Hornsey agreed to have a Board of Health in 1867. Parishes had been responsible for the care of their own poor and unemployed since the age of Elizabeth and also looked after the highways. But many aspects of community welfare were not covered in early Victorian times. Public health problems eventually produced legislation to extend the powers of local authorities to regulate drainage, water supply, and new buildings. The Local Board offices took the place of the room above the pharmacy and post office in the High Street where the Hornsey Vestry used to meet in the 1850s and early '60s. After the formation of the Hornsey School Board in 1875 the building was used much more. The premises remained in use until the Town Hall was built in Crouch End in 1934. The future Lord Southwood then acquired the derelict building opposite the entrance to his residence, and had it demolished. The site remained empty till the 1960s.

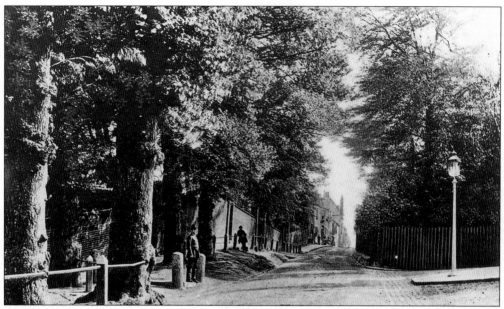

In Southwood Lane, in 1907, opposite the junction with The Park, a policeman stands under the ancient elms at the site of Highgate's public well. Drinking water was drawn from here before a piped supply became available, some being carted around the streets and sold. Shops at the top of Wells Hill are just visible. In the other direction the road led to the Mus Well, a place of pilgrimage in the Middle Ages for its supposed miraculously curative properties.

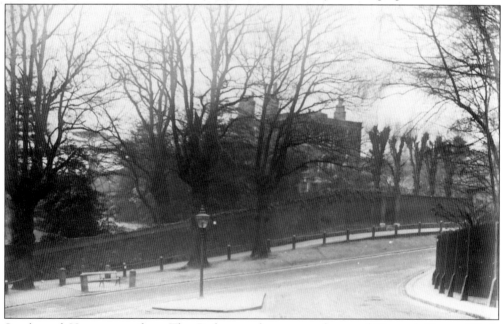

Southwood House, seen from The Park, was the country home of General George Wade (1673–1748) after his retirement. He had commanded the English troops in Scotland during and after the 1745 Rebellion. He had become famous for road building as a means of 'pacification'. In 1951 the mansion, then derelict, was bought by Hornsey Council and on the night of 23 February 1953 was gutted by a mystery fire.

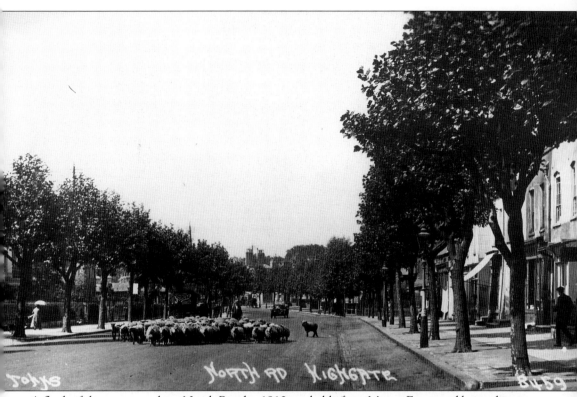

A flock of sheep comes along North Road c. 1910, probably from Manor Farm, and being driven either to market or to the pastures of Kenwood. The width of the roadway is a relic of the former main road, and so are the shops. They stretched from Highgate School's entrance to Castle Yard; before the 1890s, further. The last of the commercial properties was demolished in the early 1980s to make way for the School's Mathematics block.

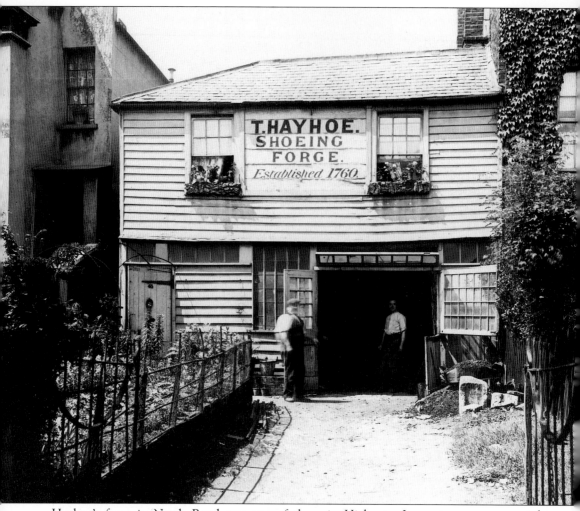

Hayhoe's forge in North Road was one of three in Highgate. Its customers were mainly coachmen and carriers whose horses needed new shoes. By 1911, with the growth of motor traffic, these two smiths must have been worried about the business, but Thomas Hayhoe carried on until his death in 1926.

Opposite: The former Castle Inn, opposite St Michael's School, *c.* 1885. It had fallen victim in the 1870s to the Temperance movement, becoming the Working Men's Club presided over by Colonel Jeakes, with a reading room and club room where coffee and cocoa but no alcohol were available from 5.00am. Lectures were given in the Drill Hall at the end of the adjoining inn yard (left) which was made into a public road in 1892.

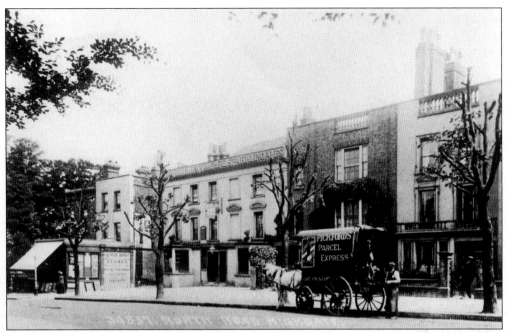

The grocery and Wrestlers Inn *c.* 1906. They remained after terraced houses of the 1890s replaced the rest of the row of shops stretching north from Castle Yard. The Toyne family had run the grocery from the 1830s to 1905 when the Lewis Brothers took over. Oakeshotts' from 1934, the grocery survived until the 1960s when it became a restaurant.

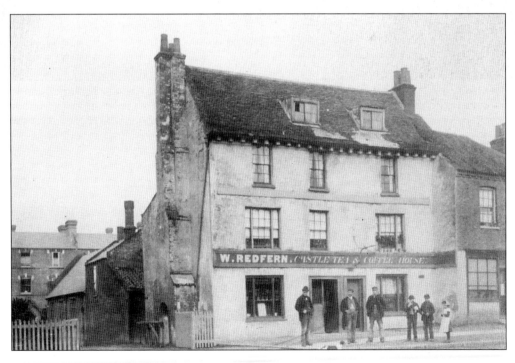

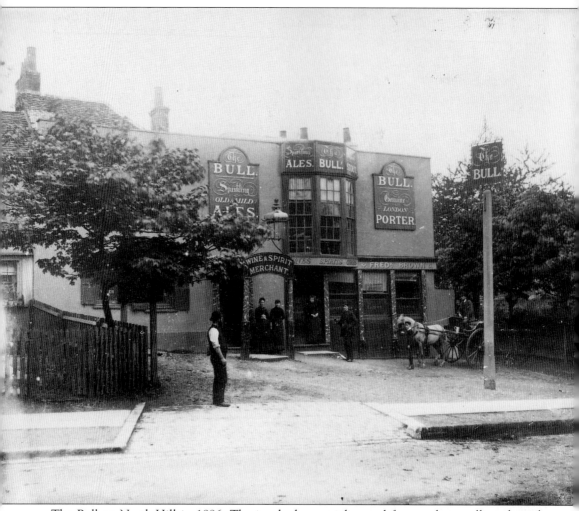

The Bull on North Hill in 1886. The inn had a special appeal for people travelling through Highgate, partly because of the parking space in front and the garden (right). Its most famous customer is probably that convivial painter of genre scenes, George Morland (1763–1804), who often stayed there to escape his creditors in London. Hassall's *Memoirs* of 1806 describe how he would stand outside and hail passing vehicles and stand drinks for visitors.

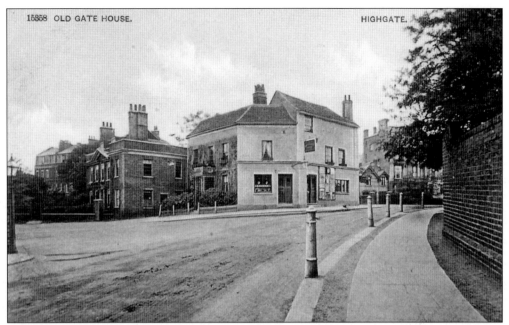

The Gate House, *c.* 1904, opposite the wall of the disused graveyard by Highgate School, was about to be given a facelift. It was itself the result of re-building in the eighteenth century when the narrow tollgate supporting two storeys had been removed and a separate gate installed. Next door, Apothecary House was formerly the home of the Wetherells, Highgate's surgeons for several generations. Beyond is Grove House, a boys' school from 1725 to 1930.

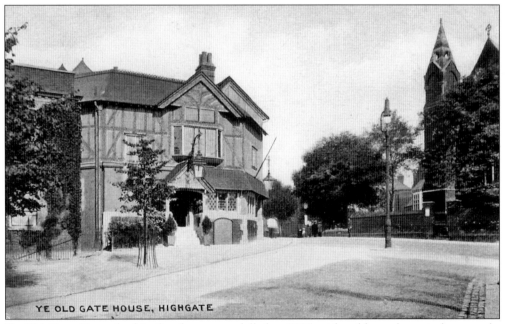

YE OLD GATE HOUSE, HIGHGATE

Ye Old Gate House had in fact been remodelled *c.* 1905 with gables, a bay window, mock-Tudor half-timbering, and a separate assembly hall at the back.

49

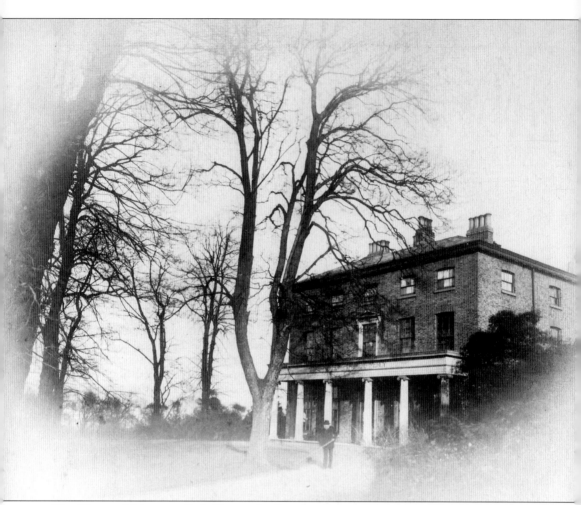

The House of Mercy in Park House, the London Diocesan Penitentiary for so-called fallen women, was one of 25 church 'penitentiaries' established in England by the 1880s. It had been founded in 1855 after the house had been a children's asylum for a few years. Before that it was the residence of William Cooper Cooper whose grandfather had built it *c.* 1800. In the eighteenth century Addison's Brewery had been on the site and underground brick tunnels forming cellars were re-discovered in the 1980s. Little is known of the earlier history, but the elevated position by a main road, with a good view north, suggests a military use. Indeed, after the Civil Wars the site is frequently referred to in the Manor Court records as 'the Bulwarks' of Highgate.

Opposite: Cowley's Cottages in 1911, on the west side of North Hill, where Hollings the builders were shortly to set up a business. Part of an earlier, more rural Highgate, they had an open space in front which was once 'Bell's Green'. They were incorporated into the builders' premises and demolished when the site was sold on Mr Hollings's retirement in 1986.

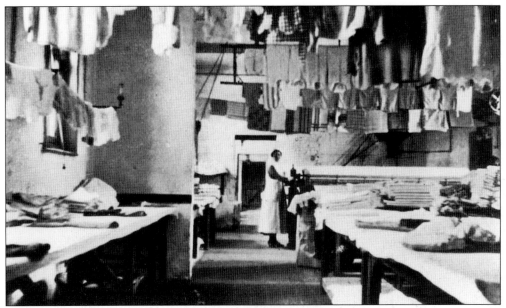

The laundry of Park House in the 1920s provided most of the regular income for the House of Mercy, having a large local clientèle. The penitentiary had been taken over by nuns in 1900 and the 'penitents' were meant to work in silence. The girls were unmarried mothers rather than prostitutes as in Victorian times, and they worked in the laundry until the birth of their babies. In 1940 the establishment was closed and sold to Hornsey Council. After the War they pulled down the house and erected the seven blocks of flats called Hillcrest.

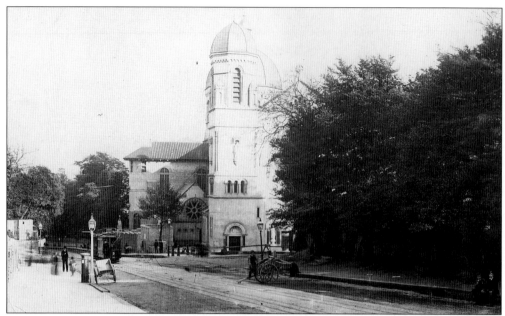

On Highgate Hill on 10 June 1892 a tram ascends by cable, unhindered by other traffic. The Italianate Retreat by St Joseph's Church, a residence for monks and priests, was built in 1858.

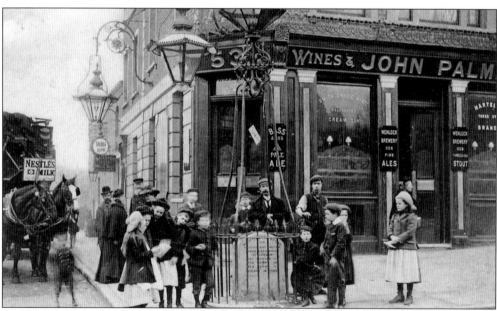

The Whittington stone in 1905 recorded, as it still does, the dates of Sir Richard Whittington's official posts between 1397 and 1420, including being Lord Mayor three times. The present sculpted cat on top of the stone was added much later. Highgate New Town and the post-war additions to Whittington Hospital have radically changed the appearance of the traditional turning place of storybook Dick Whittington, and the public house has been completely re-built and re-sited further back.

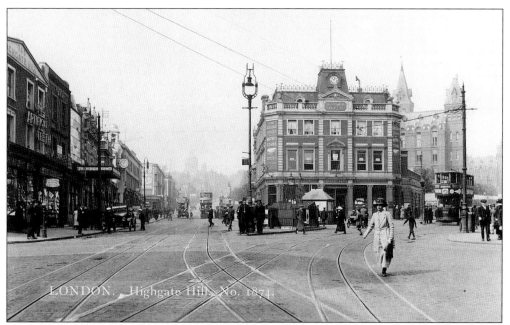

Archway in 1920 is still a crossroads, not a giant roundabout. The tallest building (right) is the Whittington Hospital, erected in 1877 as the Holborn Infirmary to serve the destitute. The Archway Tavern (centre) was built, originally with only two storeys, after the construction of the Archway Road, in a strategic position between the old and new main roads. On Highgate Hill the trams were replaced by trolley buses in November 1939.

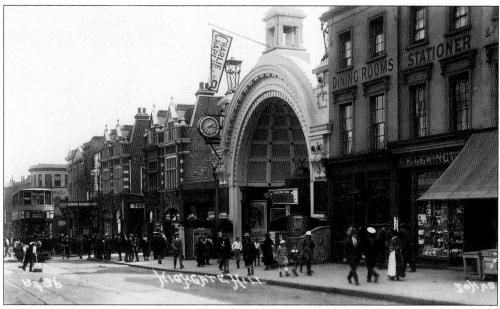

The Electric Palace cinema in 1922. Opened in 1912 near Highgate Underground station (re-named Archway in 1939), the cinema was demolished in 1958 to make way for a shopping complex. Note the crossing sweeper in front of the tram sweeping up manure from cart horses.

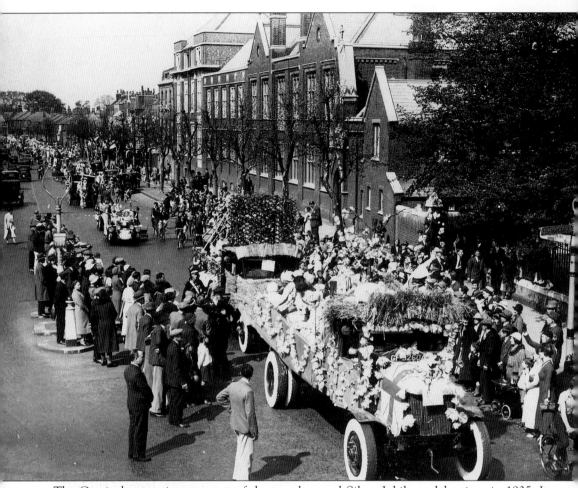

The Carnival procession was part of the popular royal Silver Jubilee celebrations in 1935. It passes along North Road by Highgate School.

Five
Hub of the Town

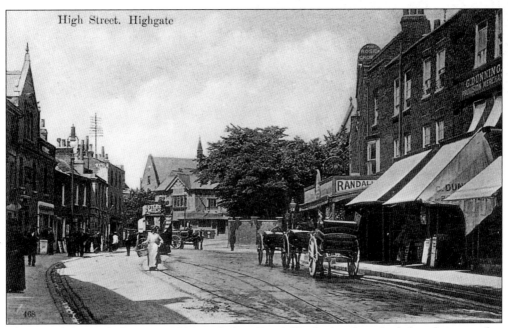

High Street. Highgate

The top of the High Street, c. 1914, including Randall's the butchers (right) with its wooden canopy to protect the meat from the heat of the sun in the era before refrigeration. Animals arrived on the hoof and were driven down the cobbled cartway. Bullocks were slaughtered in a small room with hoisting tackle. Calves were kept in pens in the back yard. The butcher's closed in the 1960s but much of the equipment has been preserved by the new owners.

Miss Cutbush's newspaper shop at the very centre of the town was a social magnet. Next door was the old Watch House, replaced in 1860 by the police station round the corner in West Hill. The passageway into Pond Square led to the stables for the police horses. The magistrate's court sat in the upper room of the Gate House until 1878 when Northfield hall in North Road was built.

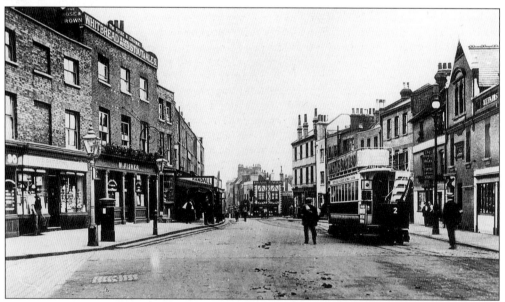

The High Street c 1914 included W.E. Burrows the grocers (extreme left) established in 1847 and a family business until c. 1960. In the 1880s and 1890s it was also the Post Office. On the opposite side are Attkins the pork butchers, in business from the 1820s, who became famous for their sausages. They continued until the last Attkins retired in 1967. Ahead, centre, is the Angel Inn, with a pedigree going back to the fifteenth century, and often the meeting place of the Manor Court of Cantelowes.

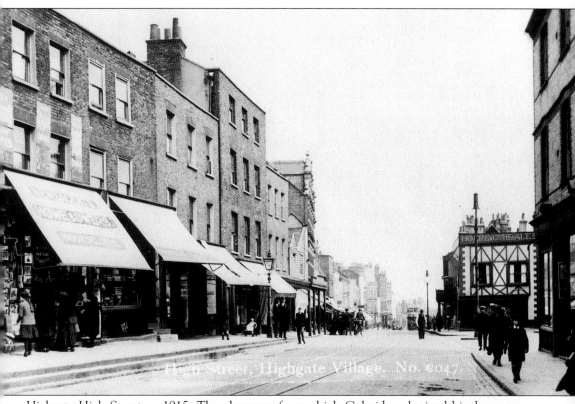

Highgate High Street, *c.* 1915. The pharmacy from which Coleridge obtained his drugs was founded *c.* 1800 somewhere near Townsend's Yard, but in 1833 the apothecary Thomas Henry Dunn moved into the central, taller unit of a new terrace of three shops (left, by the lamp post) put up by the local builder Townsend. The Pharmacy had a long, purpose-built extension behind the shop including a laboratory, 'grinding house' for the pulverising of drugs, and a warehouse. Here many items which pharmacists would not now be expected to produce themselves were manufactured, besides medicine: flavourings, condiments, cleaning materials, and mineral water. Dunn was also Highgate's chief postmaster at that time. His successors greatly expanded the mineral water side of the business and in 1870 this became a separate company. But by 1888 competition from big firms like Idris and Schweppes had forced it out of business. It was forgotten until the underground cistern and associated pipework were accidentally discovered in 1977.

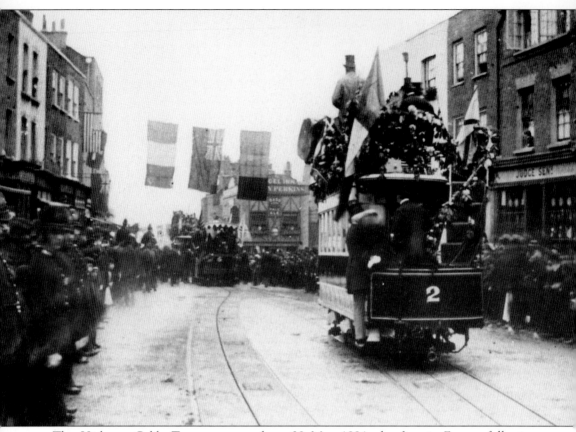

The Highgate Cable Tramway opened on 29 May 1884, the first in Europe following a successful début in San Francisco. The attendant jubilation was understandable for although Archway had been linked by horse tram with the City by 1873 and with the West End by 1882, Highgate had not. Highgate Hill had been an insurmountable obstacle for tram horses. Now the cable cars came up as far as Highgate School. The controls were in the High Street between the Duke's Head and the White House. But a snapped cable led to a horrifying accident, and the service was suspended between 1892 and 1897 and finally closed for electrification in 1909.

Opposite: One of the new electric trams standing at the terminus in 1914 outside the grocer's opposite F.P. Cockerell's School Chapel. Notice the delivery boy's bicycle.

Dodd's forge in the High Street, vacant *c.* 1894, was a victim of the motor age. A smith had been there by 1664 and the first Dodd by 1746. After the forge was demolished in 1895, a printer's shop was built on the site, but this in turn was demolished in 1939 to give more room to turning trolley buses.

Highgate's more famous residents have included Andrew Marvell (1621–1678), poet and opponent of the Royalists. He lived in a cottage on Highgate Hill, later acquired by Sir Sydney Waterlow, and demolished. Marvell was a member of Richard Cromwell's parliament in 1659 and was returned again in 1660 and 1661 after the Restoration. He was a well-educated and thoughtful man who praised Charles I for his conduct on the scaffold in two of his most famous lines: 'He nothing common did nor mean/Upon that memorable scene'.

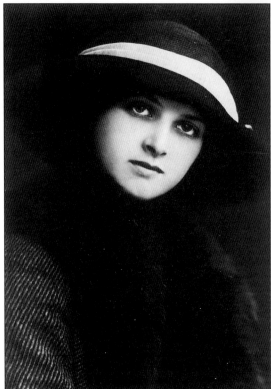

Gladys Cooper (1888–1971), the English actress who leapt to fame in 1922 and was later successful in films, lived in Number 1 The Grove in the early 'thirties, with her second husband, Sir Neville Pearson. They were among the celebrities who were invited to the annual pre-Wimbledon tennis parties in the grounds of the Witanhurst mansion on West Hill by their neighbour Lady Crosfield.

Six
The Highgate By-Pass

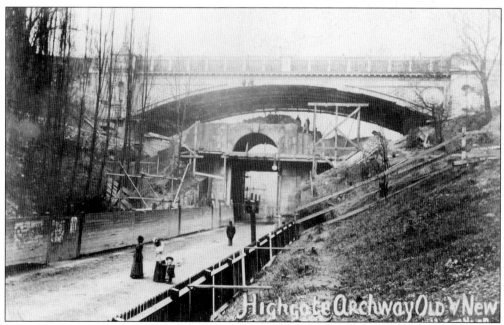

The original Highgate Archway was demolished in the late 1890s while the new viaduct over the widened Archway Road was being constructed. The old arch was itself a replacement for the intended tunnel under Hornsey Lane which fell in during construction of the new road early one morning in 1812.

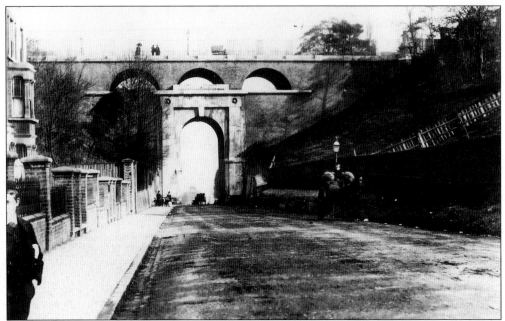

The viaduct designed by John Nash (1752–1835) was part of the scheme to bypass Highgate Hill carried out by the Archway Road Company set up by Parliament in 1809. Robert Vazie was the engineer responsible for the road. In 1886 the iron railings replaced Nash's stone balustrade which had proved tempting not only to boys demonstrating their daring, but to numerous suicides. Looking south, 7 May 1888, by amateur photographer Percy Barralet.

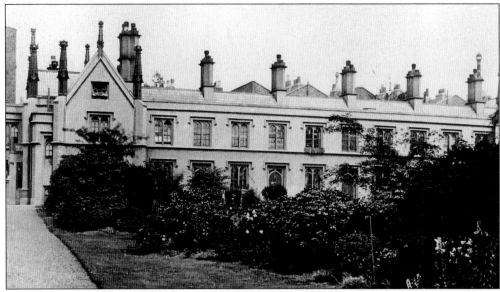

'Whittington College' consisted of thirty almshouses built in 1822 by the Mercers, Richard Whittington's livery company, at the foot of Archway Road, not far from the Whittington Stone. They were considered a replacement for the City almshouses built under Whittington's will of 1421 and since decayed. They were designed by architect George Smith (1783–1869). In the face of the impending Archway road widening scheme in the 1960s the residents were moved to East Grinstead, and the Almshouses were demolished.

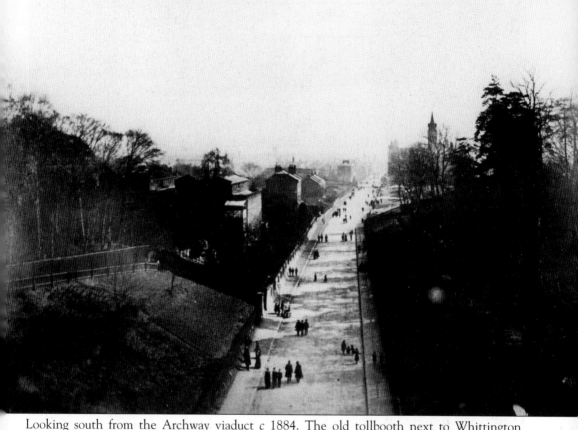

Looking south from the Archway viaduct *c* 1884. The old tollbooth next to Whittington Hospital can be seen for although the toll was abolished in 1876 the gate and tollhouse were not to be removed until 1885. The brickfield (right) remains, and no shops have yet been built on either side of the road. The total absence of traffic perhaps explains why so many people are not using the pavements.

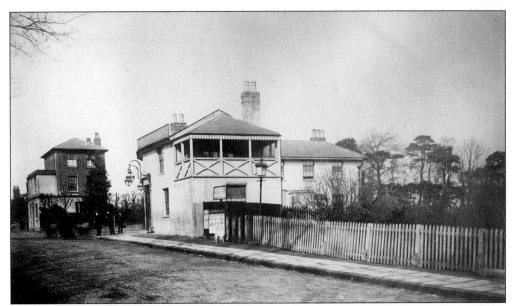

The Woodman Inn at the junction of Archway Road and Muswell Hill Road has, in 1884, changed little since Pollard depicted it with a stage coach outside. Charles Ramsway has been the landlord since the 1840s and will not retire until the 1890s. The shadows of trees in the road show that no shops have yet been built opposite. But small changes have occurred. Twenty years before, no pavements existed and there was a hedge instead of the fence. Bigger developments are imminent.

At the junction of Jackson's Lane (left) and Shepherds Hill (right) with the main thoroughfare, c. 1897, Archway Road is still a country road. Something is being constructed opposite the station but it has not yet blossomed into the Queen Anne style Grand Parade of shops. From Jacksons Lane the houses in Southwood Lane can be seen across the field. At the top of the little road down to the station, a notice points along Shepherds Hill where houses are for sale or to let.

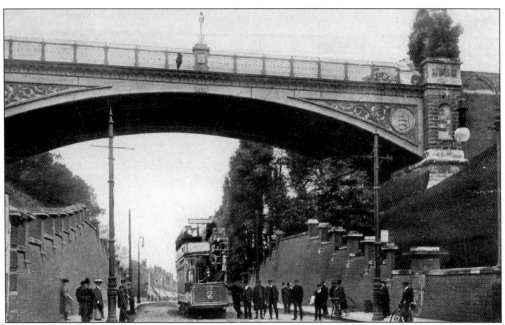

Workmen pose with one of the new electric trams under the Archway after the service started in 1905. Plans to widen Archway Road to accommodate trams that would enable people from a wider area to reach the woods had been discussed since the 1880s. But the viaduct itself was the boundary between Hornsey and Islington, and, after 1889, between London and Middlesex, and agreement foundered on questions of financial responsibility. The central plaque gives the date 1897; this did not signify the date of completion but marked Queen Victoria's Diamond Jubiliee. The new viaduct, designed by Sir Alexander Binnie, was officially opened on 28 July 1900.

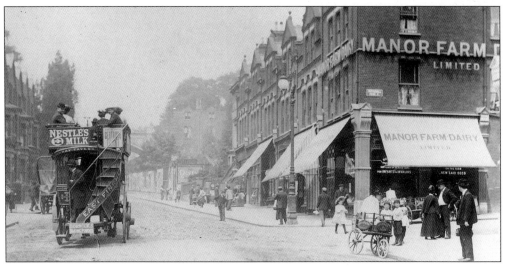

A horse bus wends its way up Archway Road in 1904 but it may not long survive competition from the M.E.T. trams to be started the following year. Manor Farm Dairy on the right was one of a chain of shops that sold milk from Manor Farm by the Great North Road, 900 acres of pasture which was first nibbled at by Highgate Golf Course and in the 'twenties swallowed up by the 'Barnet By-pass' (Aylmer Road) and associated ribbon development.

Jacksons Lane Community Centre, opposite the service road to Highgate tube station, was still being converted in 1980 from its original function to multifarious new uses. Built in 1905 as a Methodist church and meeting hall, the building, with Bath stone dressing, was designed by W.H. Boney. By the 1970s the Methodists wanted to sell, but since the building was listed by the Department of the Environment there was little prospect of developers becoming interested. A voluntary community association was formed, and in 1975 the local Council, Haringey, bought the redundant church. Latterly, they have provided funds for maintenance and staffing. Jacksons Lane has become a popular venue for folk and rock concerts, theatre productions, fund-raising events, counselling groups, and regular classes in active sports. The upper half of the nave has become a sports hall, the lecture hall a theatre, and other new rooms have been created, including a glass-roofed foyer out of the space between church and hall.

Opposite: Highgate Police Station on 10 May 1907. Built in Archway Road at the foot of Bishops Road and opened in 1902, it replaced the smaller station in Highgate West Hill. The magistrate's court was next to it with a matching gable and imposing coat of arms. Both buildings were destroyed by a flying bomb in 1944 but were re-built in modern style in the 1950s. The site of the original vicarage of All Saints' Church round the corner in Church Road has been used for police offices.

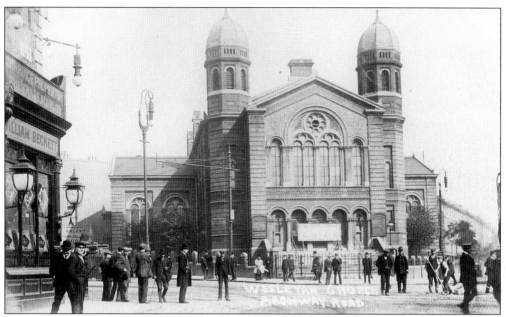

Archway Methodist Church was in a similar style to Jacksons Lane's but had been designed by John Johnson (1807–1879) more than thirty years before and built in 1872–3 as a replacement for a temporary iron chapel erected in 1864. Johnson was the architect of the second Alexandra Palace in 1875. Many Highgate Methodists regularly worshipped at Archway, until Jacksons Lane was built when most of them deserted it. The present Archway Central Hall, with a hall seating 1300, dates from 1934.

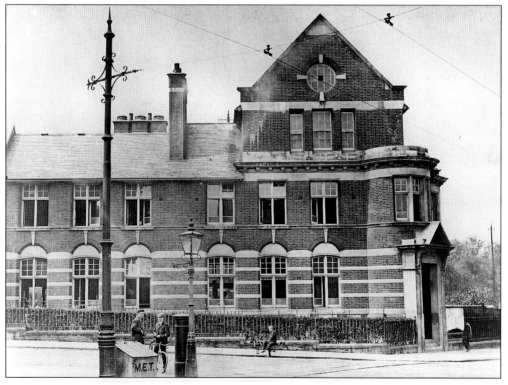

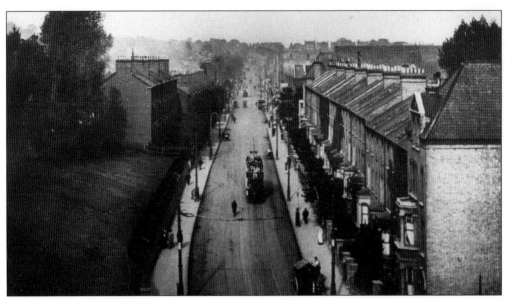

Looking north from the Archway viaduct in 1912. The Edwardian houses that have replaced the mansion called the Priory in Shepherds Hill can be seen on the skyline. Notably absent is the bell tower of St Augustine's Church, for the west end of the building will not be finished until 1914. On the right the houses nearest the camera will be wrecked by high explosive bombs in the Second World War. The grassy bank on the left will be cut back in the road widening of the 1970s.

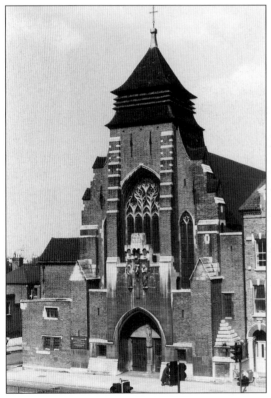

St Augustine's Church in 1980. The services and internal decorations make a special appeal to High Church Anglicans. St Augustine's was opened in 1895 when nearly complete but the architect, John Sedding, had died in the meantime. Eventually the west front was finished, by J. Harold Gibbons, but quite differently from Sedding's intentions, in German Gothic style. The stone Virgin and Child were added in the 1930s. St Augustine of Canterbury, the patron saint, is represented by a figure over the altar.

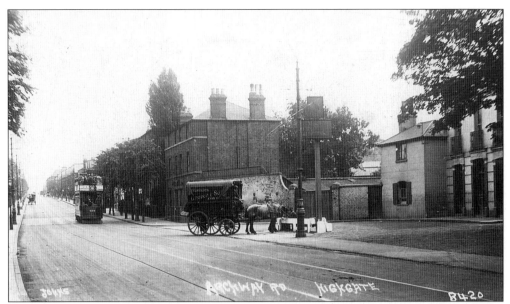

The Wellington Inn, *c.* 1906. Built strategically, like the Archway Tavern, between the new and old main roads, the Wellington opened at the same time as the Archway Road. The customers probably included local labourers as well as travellers and drovers, for about 200 yards away was the farmyard of Manor Farm, otherwise known as Lane's Farm, where Joseph Willington Lane employed 68 outdoor workers in 1881, and on the other side of the Great North Road was a commercial orchard.

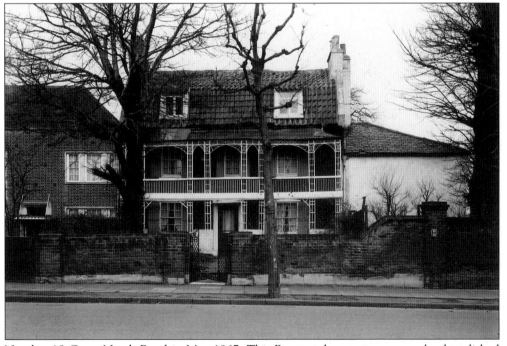

Number 18 Great North Road in May 1967. This Regency house was soon to be demolished and a close of houses called Sussex Gardens built on its land. In Victorian times the two acres were used for a commercial orchard.

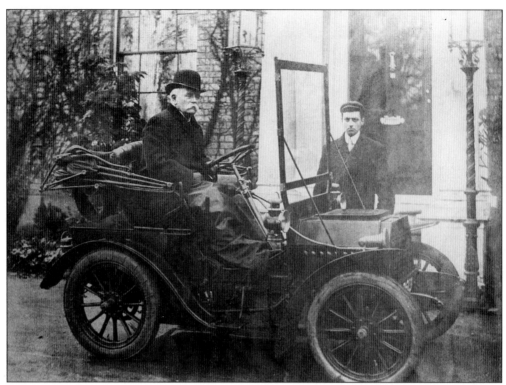

A local doctor outside his home, *c.* 1907. At Greenbank, a detached house built in Archway Road *c.* 1870, Dr Cathcart has William the house boy standing by to give general assistance with the car.

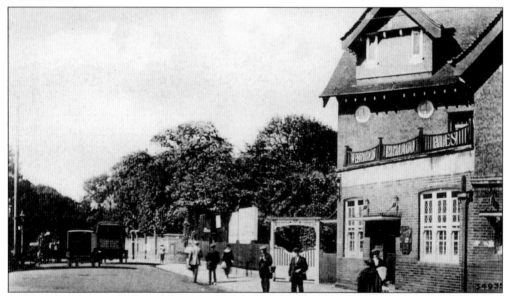

Commercial motor vehicles are in use near the re-furbished Woodman Inn, *c.* 1920. Horses are still used for heavy loads like coal, and at the nearby dip in the road to Muswell Hill carters sometimes wait for a carter coming in the opposite direction so that each in turn can make use of an extra horse to surmount the hill.

Seven

The New Highgate

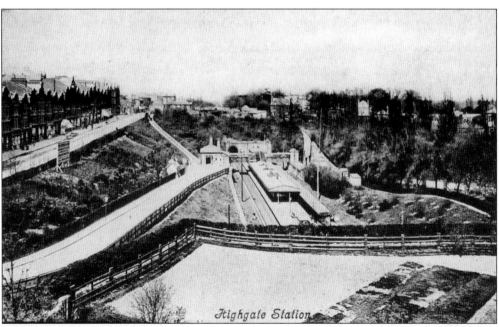

Highgate Station, *c.* 1905. Opened in 1867, the railway has wrought great changes. The slope by the station is being used by Cutbush, the Highgate Village nurseryman, to advertise to commuters, many of whom will be living in new houses, with gardens to be planted. The central platform of the station was added *c.* 1880 to cope with the extra trains put on because of suburban expansion. The parade of shops has been open for about five years.

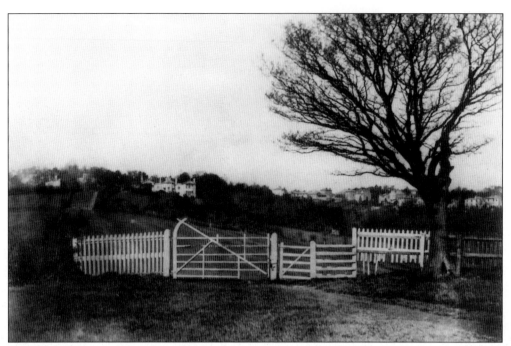

Shepherds Hill *c*. 1860, recorded by the amateur photographer George Shadbolt, is still a track along the ridgeway, where sheep often graze. The big house ahead is the Priory, built on part of the former Common in the 1820s. The only other house on the hill is Shepherds Cot Farm, nearer Crouch End. From *c*. 1870 the Priory was occupied by Robert Stedall, a well-to-do ironfounder, and his family.

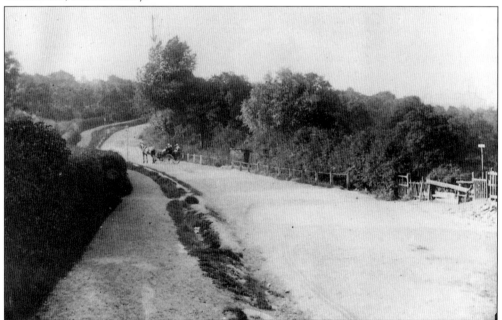

Muswell Hill Road in 1885 is still rural and its old name of Southwood Lane as far as St James's Church has only just been given up. Highgate Wood is on the left. On the right is the entrance to a disused tip where Bond & White started their builders' merchants' yard in the 1920s.

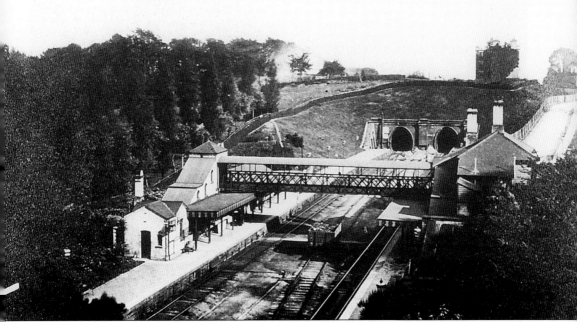

Highgate Station, *c.* 1879. The basic layout was the same when the station opened in 1867 as part of the Edgware, Highgate & London Railway from Finsbury Park. In December of that year the double line was extended to Finchley. After the Barnet line opened in 1872 there were 24 trains a day each way. Top right are Coleridge Buildings, a block of 46 artisans' flats erected the same year as the station (and destroyed by a direct hit by a flying bomb in the Second World War). Next to it (right) is the Birkbeck Tavern in Archway Road (now the Shepherds), built about the same time; the name commemorates the Birkbeck Freehold Land Company which developed the area immediately south of the station, beyond the tunnels under Shepherds Hill. Artisans' small terraced homes were laid out here, and a homogeneous community developed. Beyond it, on land which became available in the 1880s, a middle-class neighbourhood was to develop, now called the Miltons after the name used for several of the new streets.

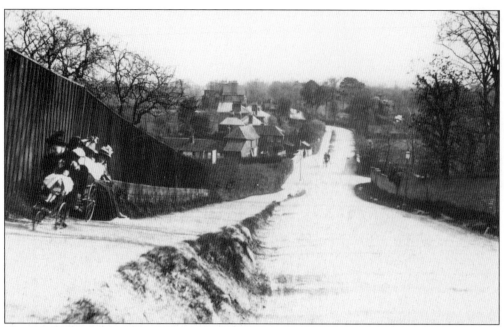

Muswell Hill Road, 7 May 1888, goes past Upton Farm (left). The railway bridge is for the branch line from Highgate to Alexandra Palace opened in 1873, but Cranley Gardens Station is yet to come. On the right, past the wall of a house called The Hall, is the turning into Woodside Avenue. The big house where the road rises, centre left, is Woodlands where the Lehmanns live.

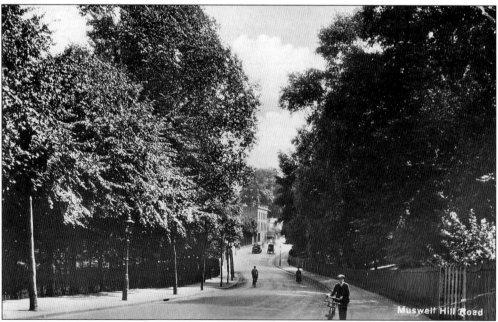

Muswell Hill Road, c. 1905, has seen the opening of Cranley Gardens Station. The new amenity came in August 1902 following the building of houses on the green-field sites of Cranley Gardens and Onslow Gardens. Further developments are anticipated and an urban-looking tall parade of shops (centre) has been erected near the station.

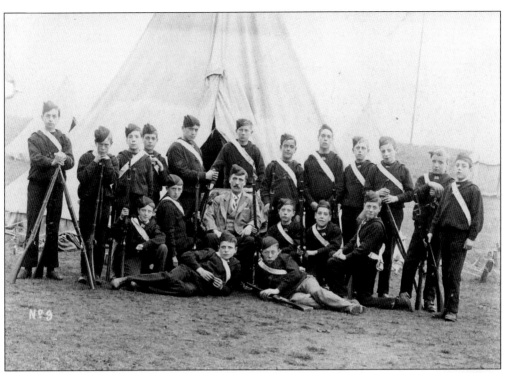

The London Diocesan Lads' Brigade, led by Captain Charles Low of Claremont, The Park, Highgate, in camp at Littlestone-on-Sea in 1895. Boys like these were a focus of middle class attention. With the extension of public transport new areas were given over to housing and commuters were soon made aware of the district's social problems. The new arrivals developed a network of charitable enterprises, as previous Highgate residents had done a century and more earlier.

Springfield Cottages in North Hill were decorated for Edward VII's impending Coronation on 9 August 1902. Built in 1877, the year Highgate Board School opened alongside, they were part of the development of northern Highgate that followed the railway. Further down the road is scaffolding on a new terrace of houses being built.

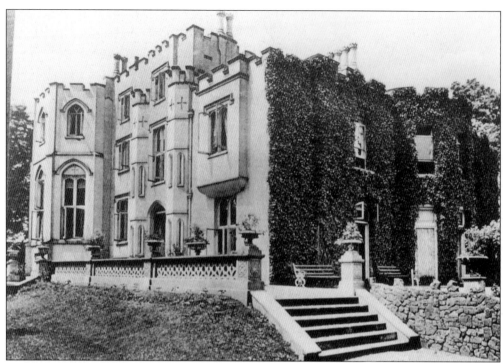

Southwood Hall, on the site of the key flats of the same name near Highgate Station, was built on former common land after the Enclosures. A wealthy Nonconformist lawyer, Henry Vertue Tebbs, lived there from 1845–61, and in the 1890s John Cathles Hill, a large-scale developer and builder. It was pulled down in 1931.

From 1905 to 1930, Southwood Hall was a school under Miss Rowe. She had previously helped her sisters run Earlham in Bishopswood Road. Before 1914 there were about twenty boarders and eighty day girls. This was one of the classrooms.

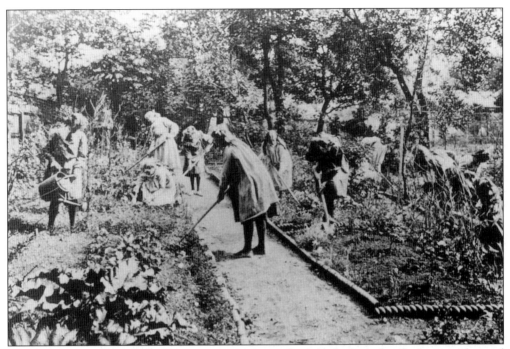

The girls were working under the supervision of a teacher who looked after the large garden and used it for nature study lessons. The curriculum at Southwood Hall was liberal and included German as well as French, History of Art taught by Miss Rowe's sister, and visits to art galleries in Italy.

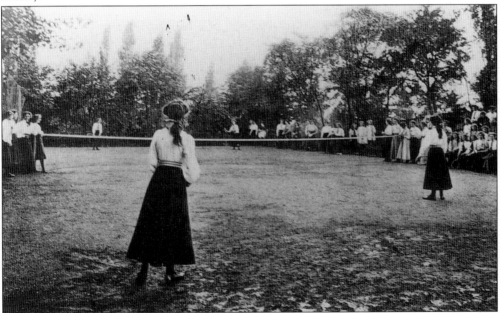

One of the tennis courts at Southwood Hall. The standard was high and matches were played against Channing House (the Unitarian school for girls on Highgate Hill) and North London Collegiate School. There was also a drill hall which functioned both as a gymnasium and a theatre for school plays.

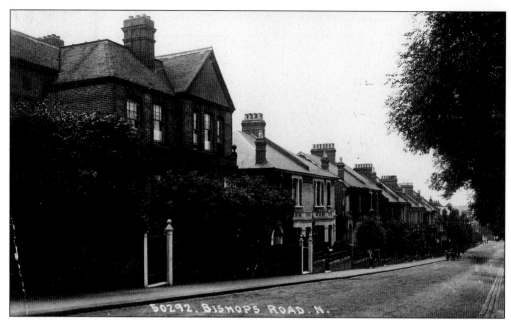

Hillcroft, No. 1 Bishops Road, was a large detached house erected in 1885 on spare ground at the end of a row of semis. In the 1920s Harry and Emma Webb lived there; he was a naval architect.

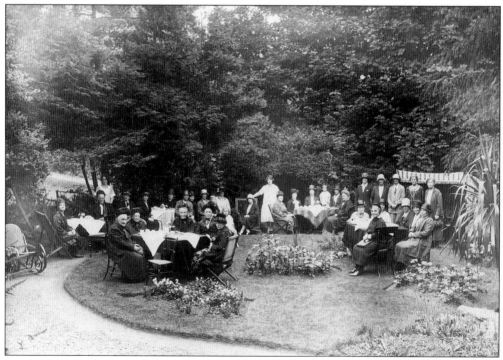

St John's Upper Holloway Women's Meeting having a party in the garden of Hillcroft was one of the hostess's recurring charitable endeavours. A garden party somewhere on the Northern Heights was an annual treat for these old ladies. In the 1920s they are still wearing Victorian bonnets.

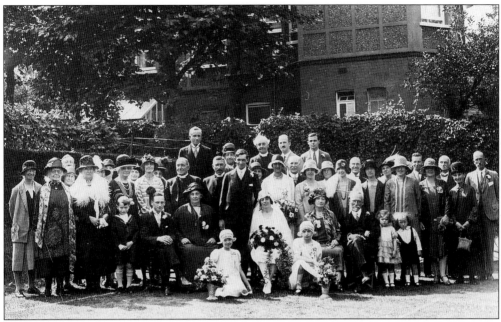

The wedding party in the garden of Hillcroft for the Webbs's daughter Clare in 1928. She married Morris Goddin, a printer. He had been brought up in Holloway and the young couple met through the Band of Hope to which they belonged at St John's Church in Holloway. Mrs Webb, a staunch Protestant, insisted the family should attend Sunday Service there in preference to the less Evangelical churches of Highgate. The house in the background was at the top of Talbot Road.

A family Christmas dinner *c.* 1929 in the Webbs's dining room.

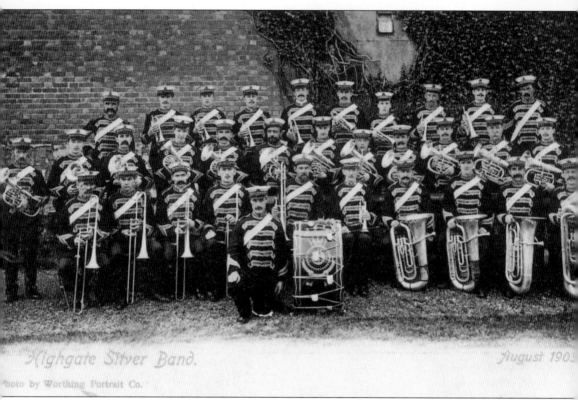

Highgate Silver Band.

August 190[?]

Photo by Worthing Portrait Co.

The Highgate Silver Band was popular for open air events. Every Sunday morning the band used to play outside Saunders the florist's opposite the Woodman. 'It was a regular meeting place', Liza Chivers remembers, 'almost a social occasion, as the young people promenaded while their elders gossiped as they listened to the music.'

Opposite: Wartime food conservation measures like these 'pig bins' in Wood Lane, seen on 8 December 1940, were nationwide. The instruction on them reads, 'Please deposit here or hand to dustman'. The 'S' sign directs people to the public shelter recently opened in the Underground station. Highgate's experience of the Second World War was in no way unusual, and many bombs fell, mostly round the railway and Archway Road.

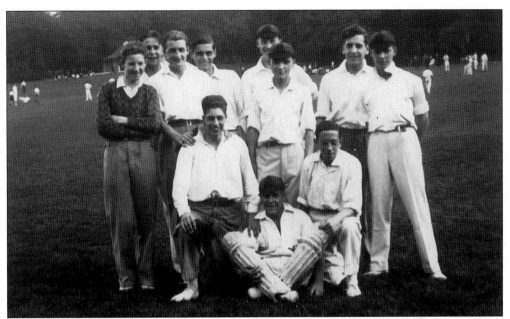

The Stroud Green Baptists' Cricket Club in Highgate Woods in 1933. Alfred Leigh (middle row, second from left), remembers the keenness of those days: 'A member of a team wanting a pitch had to be at the Cranley Gardens gates when they opened at the crack of dawn ... We had to run as fast as we could to the cricket area and stake a claim on one of the four pitches ... Persons arriving in fifth and higher places were unlucky'.

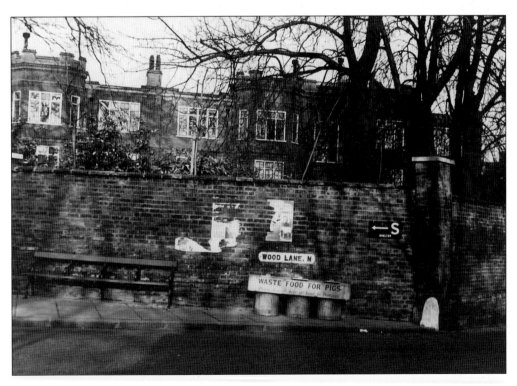

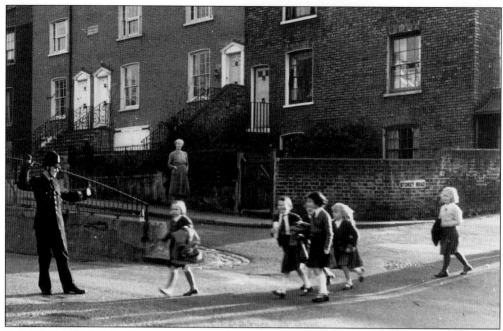

Post-War children coming out of the Council School on to North Hill in 1963. A policemen 'crosses' them over the main road, and they proceed homewards without adult supervision.

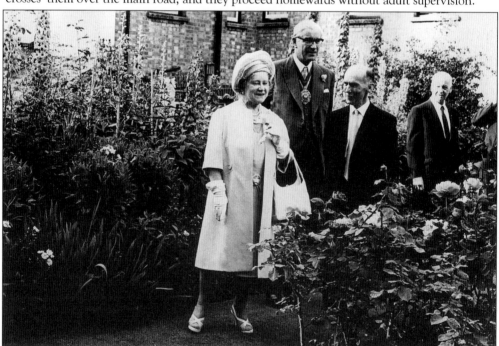

The Queen Mother admires roses in Talbot Road on 12 July 1972, to the evident delight of Mr John Daumiller, who grew them. Her Majesty's visit took place during a tour of three Highgate gardens belonging to leading members of the Highgate Horticultural Society, thought to be the oldest surviving gardening society in England. The President, Highgate Village florist Geoffrey Lewis (right), looks on. The Queen Mother's escort is the Lord Mayor of London.

Eight
Muswell Hill
Early Days

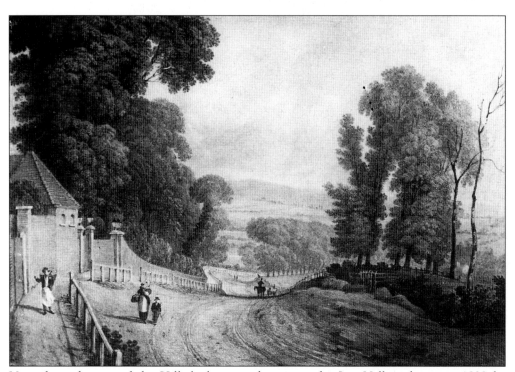

View from the top of the Hill, looking south east to the Lee Valley, drawn in 1822 by topographical artist T.M. Baynes. The entrance gates on the left are to the Grove estate, since 1863 part of Alexandra Park.

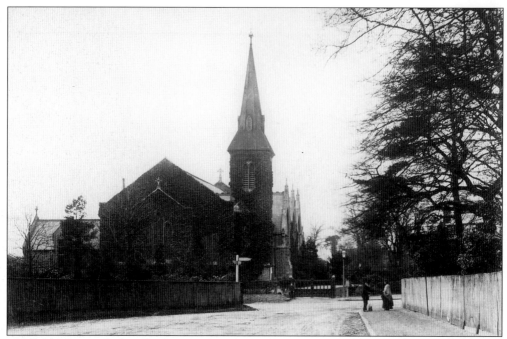

The first St James's Church, photographed 3 April 1888 by Percy Barralet. Designed by Samuel Angell, consecrated in 1842, extended in 1874, the church was replaced by a new building from 1902. Shopping parades replaced the paling fence by 1900.

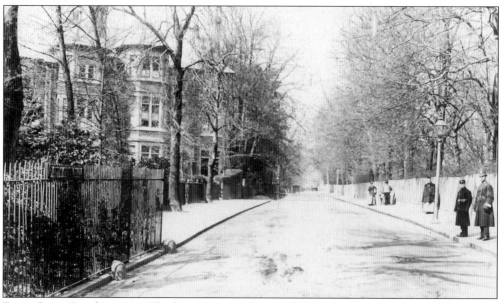

Fortis Green Road in 1890. The late Victorian houses (left) were demolished in 1936 to make way for the Odeon corner complex. The estate on the right was to be the site of St James's Parade (1900) and the Athenaeum, the latter replaced in 1966 by the Sainsbury supermarket.

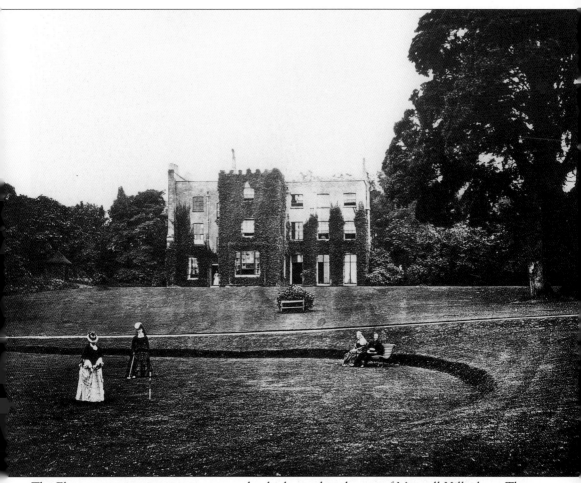

The Elms, a mansion in extensive grounds which stood at the top of Muswell Hill, above The Green Man. Estate and mansion vanished in 1900 when developer James Edmondson laid out Dukes Avenue across it and built the two Exchange shopping parades on its perimeter. The squat, three-storeyed mansion had been improved by Thomas Cubbitt and part of the grounds laid out by Sir Joseph Paxton. This photograph comes from an 1880 sale catalogue. By permission of The British Library (Maps 137.a.11.Vol. 2 No. 3).

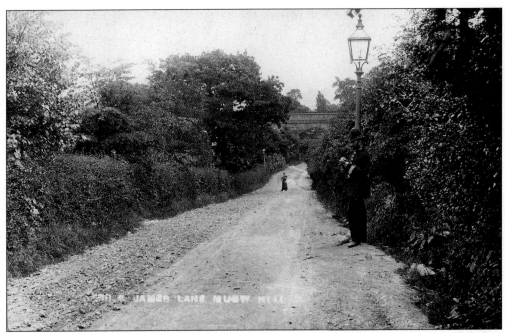

St James's Lane, 2 July 1896. The unmade-up rural lane was lit by a few gas lamps. These had been introduced into Hornsey by the Local Board from 1869 but provision of them was scarce.

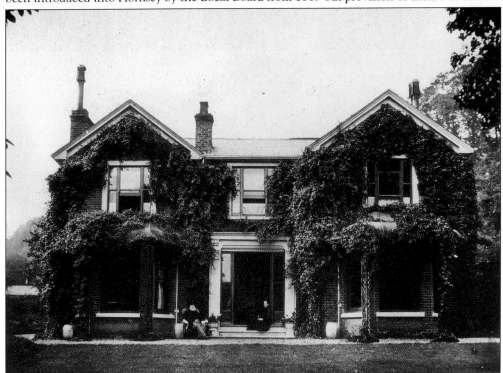

Lalla Rookh, named after a poem by the Irish poet Thomas Moore who lived here in 1817 for a few months. Situated near the foot of Muswell Hill the house was demolished c. 1900 when the Rookfield Estate was being built. In 1891 the resident was named Frederick Mildred.

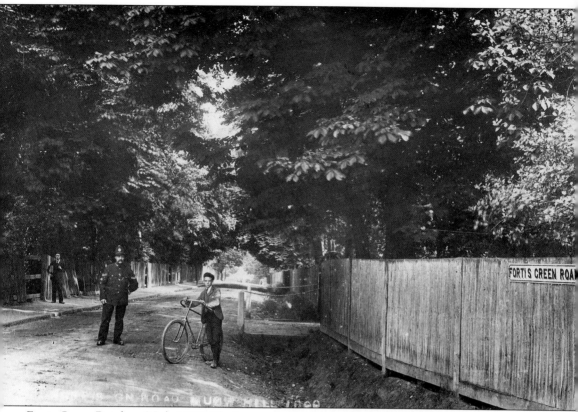

Fortis Green Road on 2 July 1896. The huge, mature trees indicate the idyllic rural appearance of Muswell Hill before development. The view is south east towards St James's Church, with the Fortismere estate on the right and the extensive grounds of The Limes estate on the left. The boy's bicycle sports thick tyres. The scene was to change very soon when Edmondson acquired The Limes and W.J. Collins was to develop Fortismere.

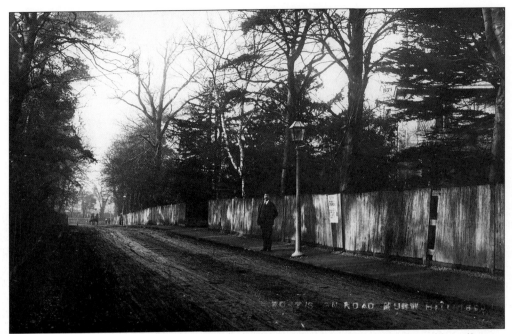

Fortis Green Road in the 1890s, a muddy track lit by gas lamps and overshadowed by tall trees. The view seems to be away from St James's Church to the north west and so the mansion on the right is likely to be Fortis House.

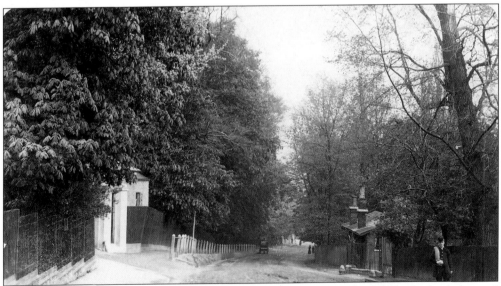

Muswell Hill in 1899, with the lodge to Grove Lodge estate on the left, both the lodge and Grove Lodge house survive. The lodge on the right served Avenue House, both of which were demolished when the Rookfield Garden Estate was laid out soon after by the Collins family.

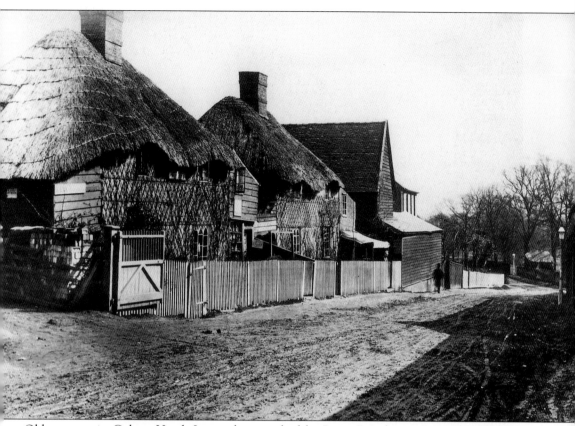

Old cottages in Colney Hatch Lane, photographed by Percy Barralet on 3 April 1888. The thatched cottages were at the Friern Barnet end of the Lane and were to survive until the 1920s. A thatched house also stood lower down Colney Hatch Lane near Pages Lane. Colney Hatch Lane is part of a very ancient route from London to the north. It was once known as Muswell Hill Lane.

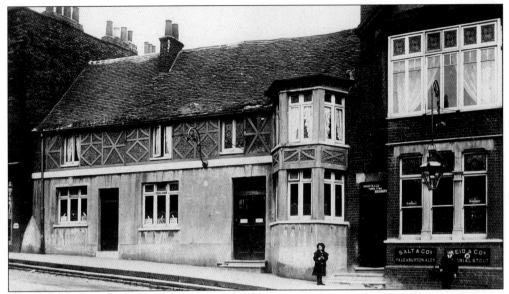

The Green Man has stood at the top of Muswell Hill serving travellers for centuries. An alehouse recorded for Muswell Hill in 1552 is most likely to be this stone-built inn. The brick hotel extension on the right was added in the late nineteenth century and is still recognisable, although the whole building has been reconstructed.

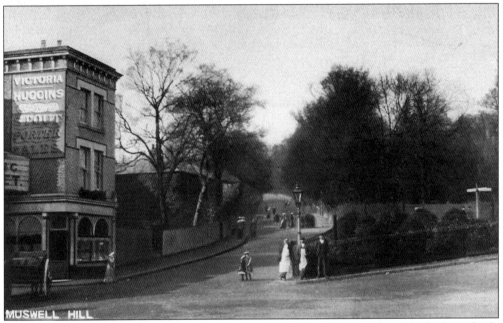

The foot of Muswell Hill at the junction with Park Road and Priory Road, with the vehicle entrance to Alexandra Park on the right. The building on the left is an addition to the 1817 public house now known as The Victoria Stakes, still surviving. Traffic lights now control this junction. An Edwardian view.

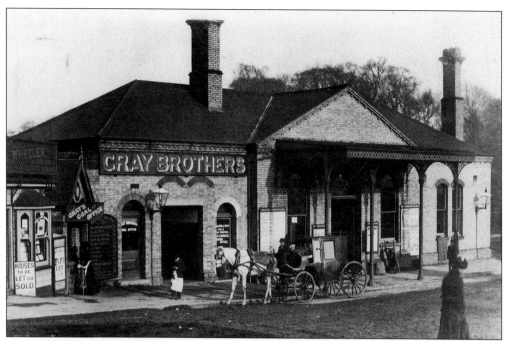

Muswell Hill railway station was opened next to The Green Man in 1873 on a new branch line serving Alexandra Palace. Horse carriages were made available for hire from 1897 by the Green Man landlord. The last passenger train ran in July 1954 and the building was later demolished.

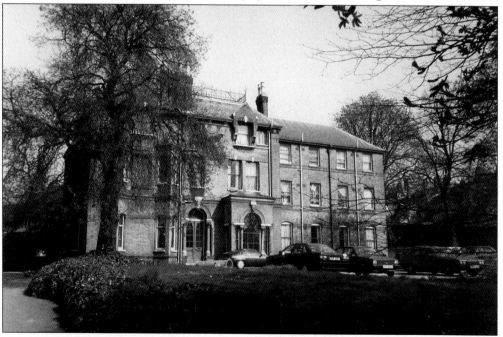

Norton Lees in Woodside Avenue is a surviving example of Muswell Hill's Victorian mansions. Built in 1875, it was bought in 1927 along with neighbouring Rosemeath and Leawood, by St Luke's Hospital. Each house stood in $2\frac{1}{2}$ acres. Built for Harry Atkin, a silversmith, Norton Lees is named after a Sheffield district.

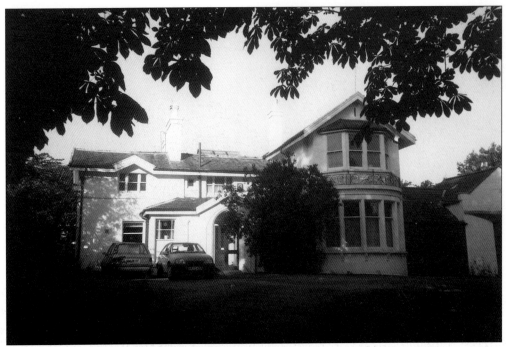

Colney Hatch Lane was lined on its west side by villas, many occupied by Londoners seeking a rural retreat. No. 3 is one of the few which survive and dates from the 1840s. The sites of others are now blocks of flats. The photograph dates from 1991.

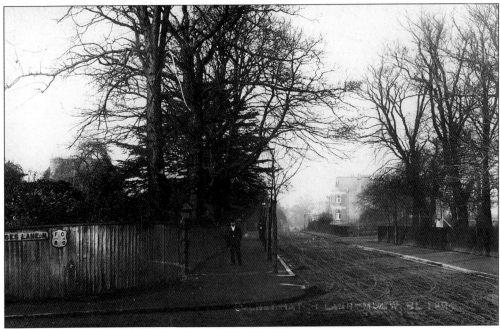

Pages Lane on the left joins Colney Hatch Lane, a corner now occupied by a petrol station. This January 1894 view looks north before the Wesleyan Methodist Church was erected in 1899 on the corner of Alexandra Park Road on the right. The church was demolished in 1982.

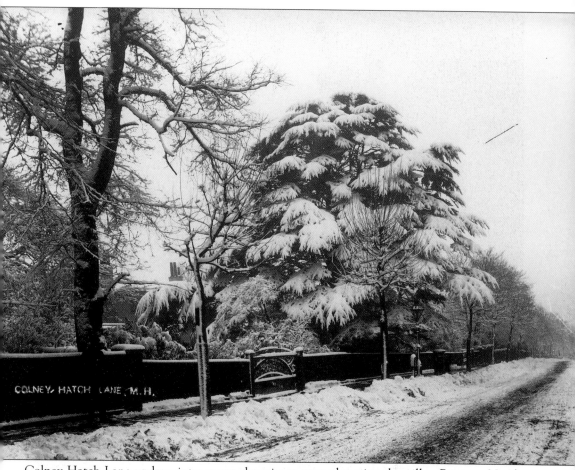

Colney Hatch Lane under winter snow, the winter trees obscuring the villas. Between North Lodge and Pages Lane they were called Oncott, Pinner Cottage, Essex View, Hazelhyrst, and Devonshire Lodge in 1894. Beyond Pages Lane the names were, past the corner house, Essex Lodge, Thatched House, Westfield, Melford Lodge, Carisbrooke Lodge, Laurel Bank, Cedar Lodge, and Thirlstane. They each had front gardens with carriage drives and long rear gardens.

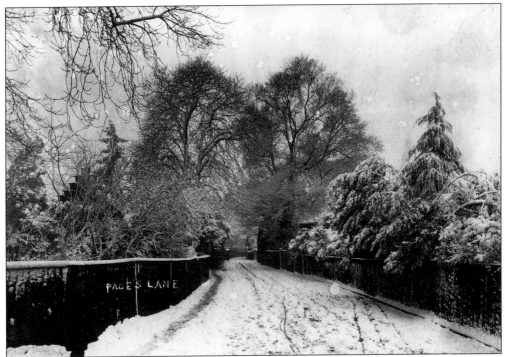

Pages Lane in winter before being widened and developed on the north side (right). This ancient route was known in 1611 as Jones's Lane. The tall, mature chestnut trees in the grounds of North Bank have been dated to *c.* 1650.

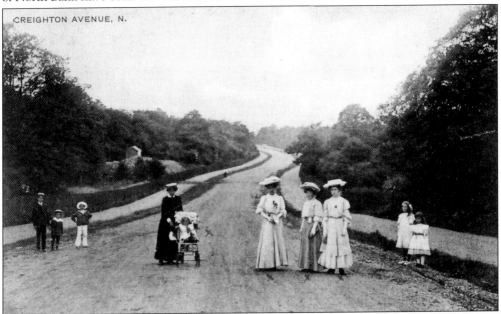

CREIGHTON AVENUE, N.

Creighton Avenue was laid out by 1900 and apparently named after Dr Creighton, Bishop of London 1896-1901. Curving round from Pages Lane to East Finchley, it cut through Coldfall Wood, which occupied 111 acres in 1895 but had been reduced to 32 acres by 1976. All that remains of the wood is on the north side of Creighton Avenue.

Coppetts Farmhouse, built in 1670, on a farm established on the north side of Muswell Hill by the sixteenth century. When photographed on 17 April 1933 it stood between Coppetts, Wilton and Sutton Roads. Soon after it was demolished.

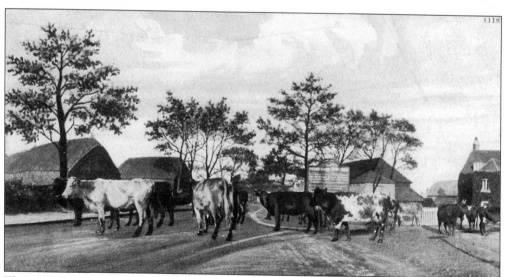

The old farmhouse in Coppetts Road was occupied in 1907 by Friern Manor Dairy Farm, later absorbed in the 1930s into United Dairies. One of the dairy's local outlets was No. 1 Queen's Parade on the corner of Queen's Avenue.

The Royal Oak stood in St James's Lane just below the railway viaduct. Photographed here on 30 May 1937, it survived until 1965 when it was rebuilt. Wooden weatherboarded buildings were typical of Muswell Hill's early days.

Weatherboarded No. 101 St James's Lane is another survivor from the days when local building was in wood. In the mid-nineteenth century it was the home of naturalist W.B. Tegetmeier, originator of the first international pigeon race.

Quaint wooden cottages on the northern side of Fortis Green, photographed on 14 May 1933. They had been built by 1851, probably by labourers who had established homes on the edge of Coldfall Wood which stretched down to Fortis Green. The cottages have been demolished.

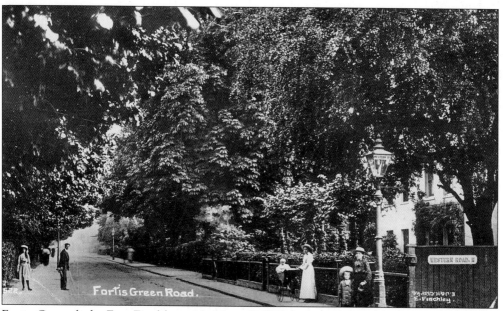

Fortis Green links East Finchley with Muswell Hill and contains early nineteenth-century buildings. Western Road on the south (right) is part of the Harwell Estate, begun in 1852. Eastern and Southern Roads also bound its perimeter.

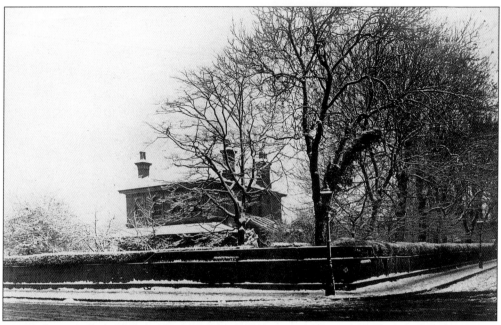

Woodside was a large house which stood on the corner of Fortis Green and Tetherdown, its grounds backing onto Coldfall Wood. The estate survived until the 1920s when flats were built on the site.

Woodside flats, which replaced Woodside House. North of them in Tetherdown was built the Congregational Church hall, with a foundation stone of 1928, as well as a purpose-built set of garages. The photograph dates from 1991.

Nine
Alexandra Palace
and Park

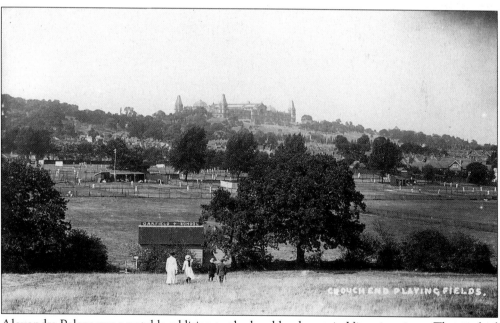

Alexandra Palace was a notable addition to the local landscape in Victorian times. The site had been chosen by architect Owen Jones who planned a glass palace on the 300 feet high eminence. This view is from the south.

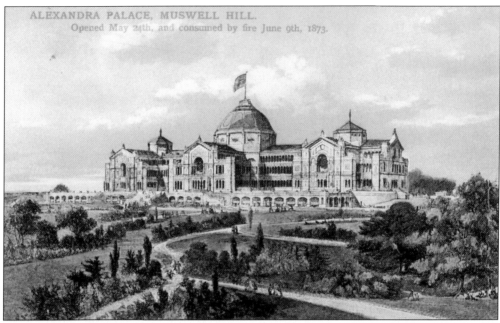

The first palace, built between 1866 and 1873 was soon burnt down. Designed by civil engineer and architect Alfred Meeson it incorporated materials from the 1862 South Kensington exhibition building which had been pulled down.

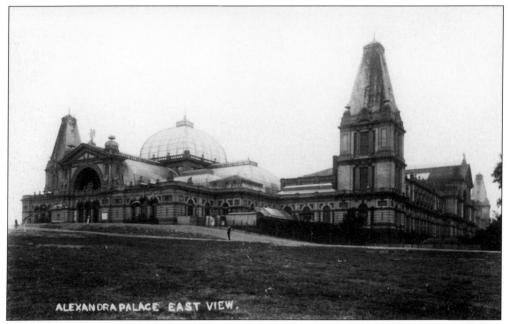

Alexandra Palace was rebuilt by architect John Johnston and reopened in 1875. Occupying nearly eight acres this substantial building has survived, but without the four corner turrets. It was badly burnt in July 1980 but was reconstructed and reopened in 1988, though parts remain to be renovated.

The banqueting hall, built 1864 was the first building in the newly opened park. In 1921 it became a ballroom. During and after the Second World War it was used by a clothing firm, Blandford, Cawdron and Bryant Ltd, and became known as Blandford Hall. It was burnt down in 1971.

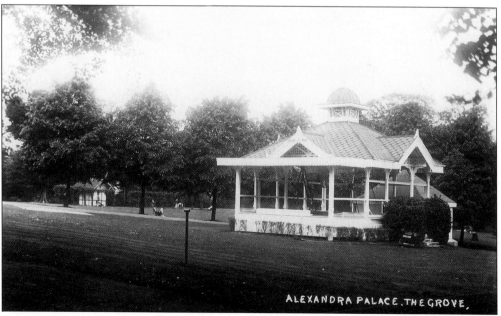

ALEXANDRA PALACE. THE GROVE.

Summer music events have always been a feature of The Grove, in the south west corner of Alexandra Park and it was provided with a bandstand and a refreshment pavilion, both in use till about the 1970s. Alexandra Park was created in 1863 when The Grove estate and a large farm were purchased.

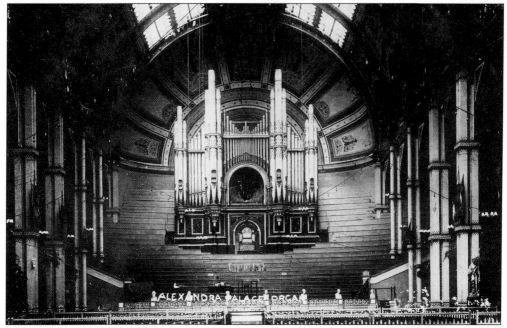

Alexandra Palace organ was built in 1875 by Henry Willis. Set in the Great Hall it was regarded as the principal organ in the UK in terms of size and design. Damaged during the Second World War it was saved by campaigning and is now being gradually restored.

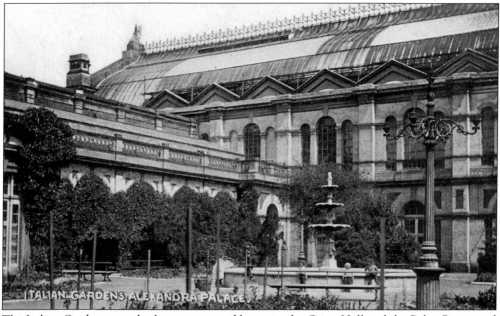

The Italian Gardens were built as a courtyard between the Great Hall and the Palm Court, and probably intended by the architect as a firebreak. It has now been roofed over and turned into the West exhibition hall. The fountain has been placed in the grounds, east of the palace.

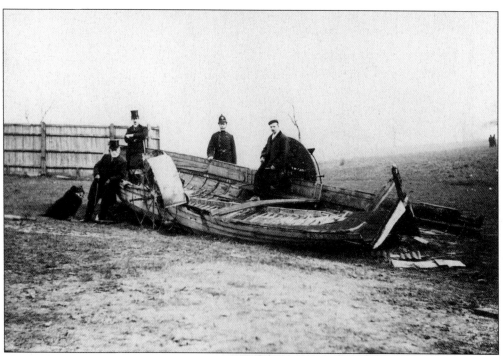

This paddle-driven pleasure boat was photographed in the park in March 1898. Pleasure boats have always been a welcome feature of the lake near the palace.

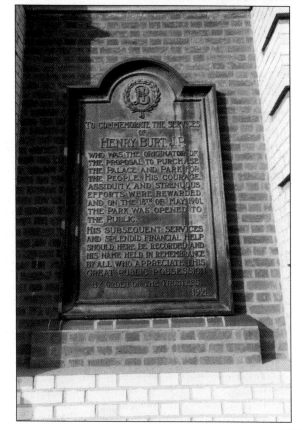

A plaque to Henry Burt and another to Edwin Sloper were placed on the south terrace of the palace in 1921. Burt led the move by a consortium of local authorities to buy the palace and park to save them from being built over. Since 1901 they have been in public ownership.

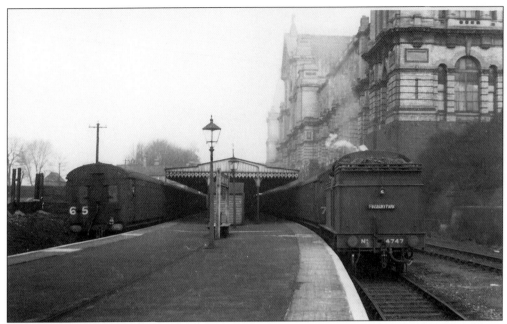

Steam trains ran to the north side of the palace, with a service through to Kings Cross from 1873 until 1954. Pre-war plans to electrify the line and incorporate it into the London Underground were never carried to completion.

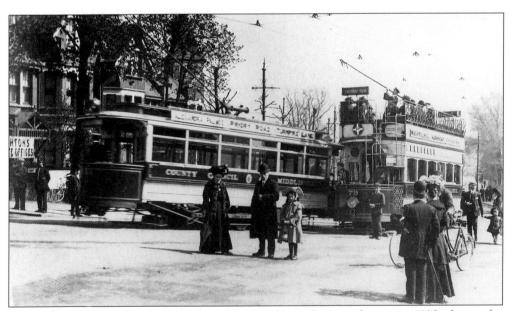

Trams seen in Priory Road. A tram service from Turnpike Lane began in 1905, the single-deckers going on to the west end of the palace. A service from Wood Green to the east end began in 1906. In 1938 they were made into a through bus service.

Ten
Edwardian Suburb

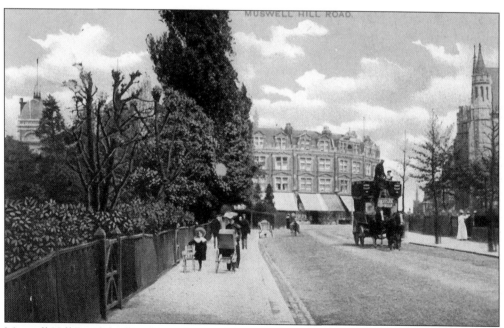

Muswell Hill Road, looking towards one of the new shopping parades, rebuilt St James's church (right) and the roof line of the Athenaeum on the left.

James Edmondson of Highbury was the builder responsible for creating the new urban suburb of Muswell Hill. Work began following his purchase of The Limes, one of the largest of the hilltop estates. He bought up many of the properties, built shopping parades and laid out avenues of houses.

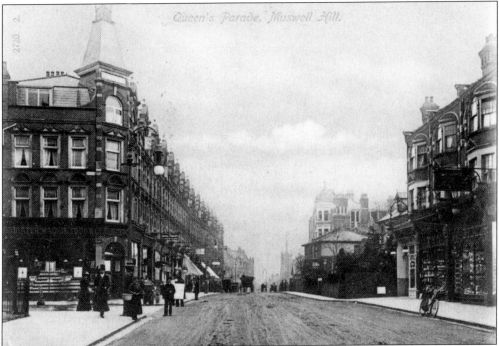

Queens Parade (left) dated 1897 was the first of the shopping parades built by Edmondson, standing between his newly laid out Princes Avenue and his Queens Avenue. Martyns the grocers have traded in the same shop since the parade was built.

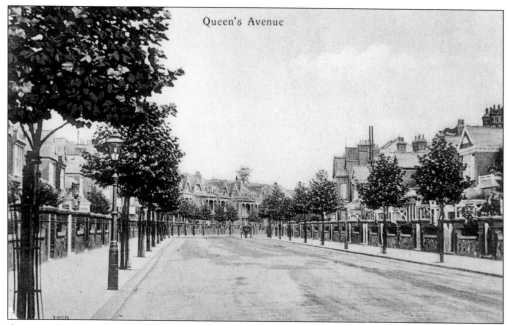

Queens Avenue was laid out by Edmondson from 1897 as the most prestigious of the new residential roads. Many of its very large houses are now hotels.

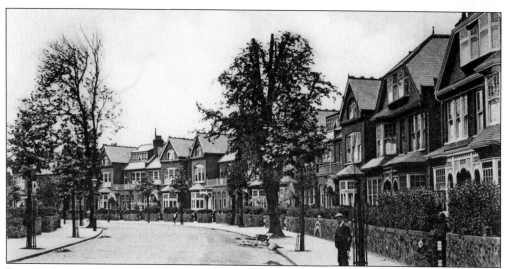

Princes Avenue was regarded by some residents as the most elite in the new suburb as well as the most central. Butlers were employed in some of the households.

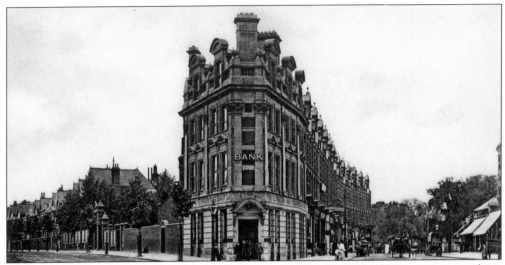

The bank building on the corner of Queens Avenue and Colney Hatch Lane, as it was then, was erected in 1898 for the London and Provincial Bank. It became Barclays in the 1920s. Note the trees (right) where the post office was to be built.

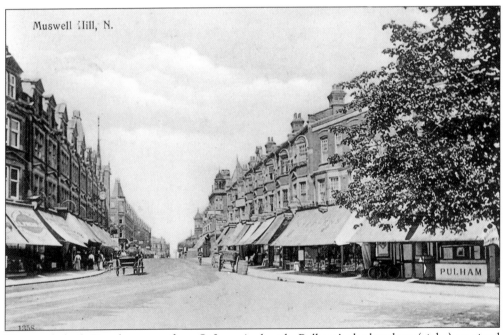

The newly built Broadway seen from St James's church. Pulham's the butchers (right) survived into the 1980s.

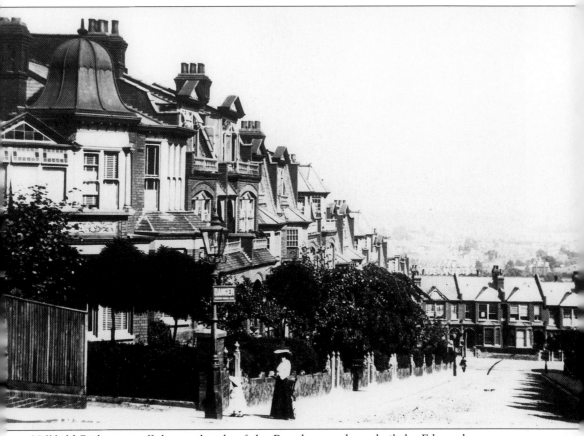

Hillfield Park turns off the south side of the Broadway and was built by Edmondson over an estate called Hillfield. From the top Broadway end fine views over London and the Thames valley are obtained. The end house, bottom left is dated 1900. Hillfield Park dog-legs to the west and joins St James's Lane.

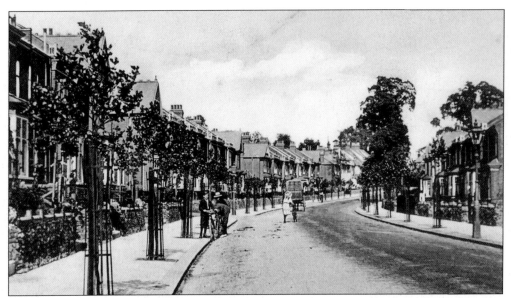

Grand Avenue was laid out between 1900 and 1905 by William Jefferies Collins, the other major local developer. Five avenues turn off it into Fortis Green Road or Fortis Green. The avenues were built over the Fortismere and Firs estates purchased by Collins.

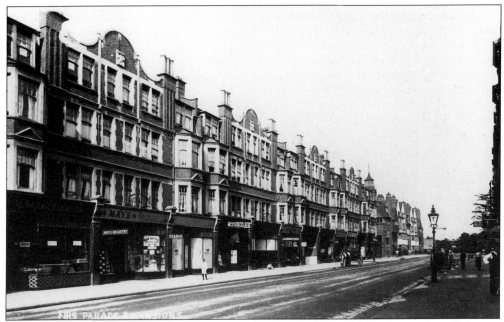

Firs Parade in Fortis Green Road was the only shopping parade built by Collins except for a small one in Fortis Green near Collingwood Avenue. Till recently it housed the Collins estate agency.

110

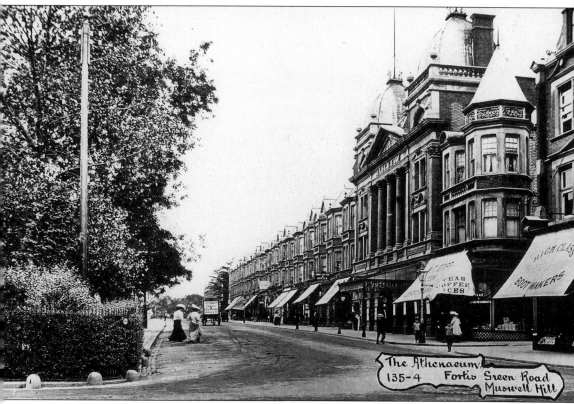

The Athenaeum stood in Fortis Green Road on a site occupied since 1966 by a branch of J. Sainsbury. It was built by James Edmondson to provide the new suburb with two local halls and other facilities. Next door to it he built St James's Parade with its 1900 date-stone. Athenaeum was a name often once given to a literary or scientific institution or building. It comes from the name of a school in ancient Rome for the study of Arts and is based on the Greek word for the temple of Athene, goddess of wisdom. The best known London example is the West End club built 1830 by Decimus Burton. The scene to the left of the view changed in 1936 when the Odeon complex was built.

The cedar tree on the corner of Princes Avenue and Fortis Green Road was preserved by Edmondson in response to public demand and he gave the corner site to the council to be kept always as a small public garden. Although the cedar tree has gone the corner site is preserved.

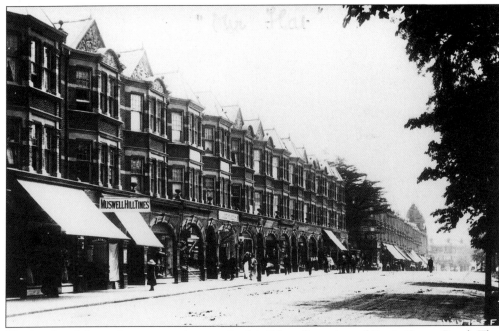

The height of the cedar tree can be seen in this Edwardian view of Fortis Green Road. The arched shop fronts are an attractive local feature in what is now a conservation area.

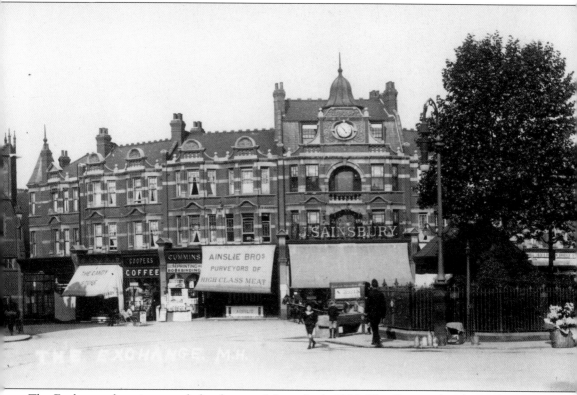

The Exchange shopping parade by the roundabout, built 1900. The Baptist church stands on the left in Dukes Avenue. J. Sainsbury traded here until moving in 1966 to Fortis Green Road. The name Cummins is still retained by the newspaper shop there today. With the coming of horse buses in 1901 the roundabout, or Plantation as it was known, became the location for their stand, evolving over the years into the place for motor buses to wait. The Victorian horse trough was shifted from nearby to the roundabout and the clock installed in 1903. The horse trough was subsequently shifted to Queens Avenue, opposite the library. The clock has disappeared.

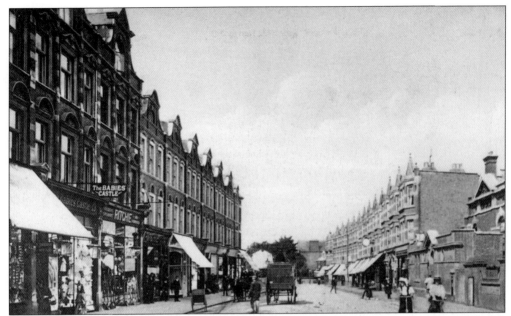

Colney Hatch Lane showing the postal sorting office, built 1902. The frontage was reconstructed in 1936. On the left is Station Parade, so called when built. The postal address is now Muswell Hill Broadway.

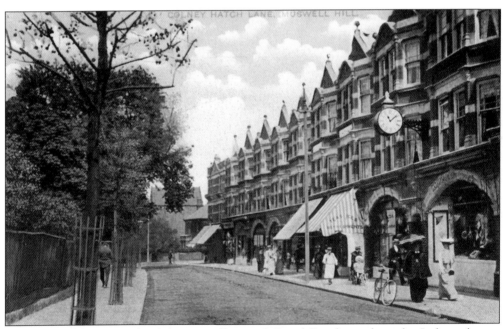

Colney Hatch Lane, north of the post office, with Royal Parade on the right. It faces the yet undeveloped North Lodge estate over which Edmondson built Woodberry Crescent in 1908.

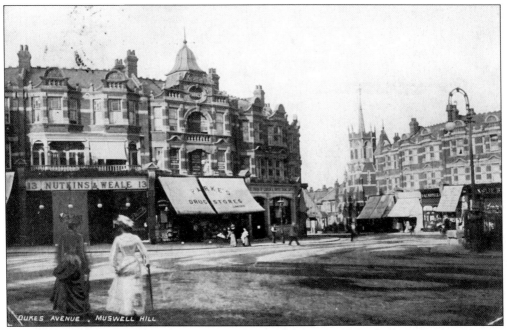

Two elegantly dressed ladies cross to The Exchange shopping parades, built each side of the top of Dukes Avenue by Edmondson. Parke's Drug Stores is now Boots the Chemists. The bank next door is now a restaurant.

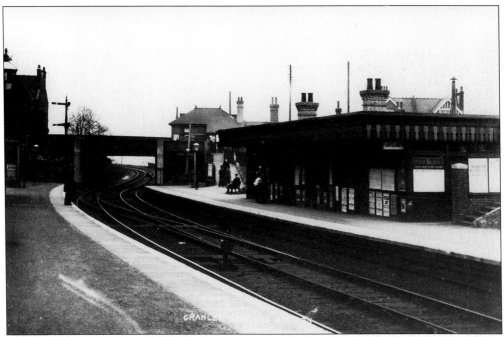

Cranley Gardens railway station was opened in August 1902, with its entrance in Muswell Hill Road. Situated on the branch line to Alexandra Palace it served the new residential areas south of Muswell Hill. It closed in 1954 and St James's school was subsequently re-sited there from Fortis Green.

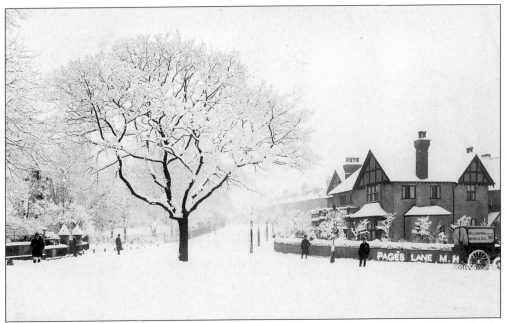

Pages Lane in winter, with a tree in the road at the junction with Creighton Avenue. On the far left stood the mid-Victorian Uzielli almshouses, replaced by 1938 by Whitehall Lodge block of flats.

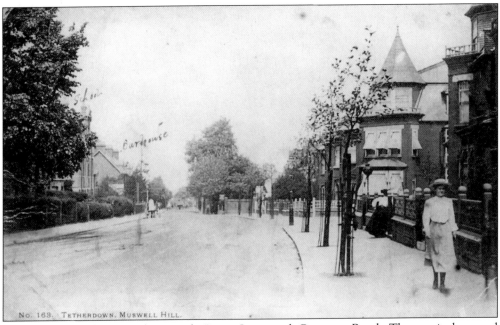

Tetherdown, looking north towards Pages Lane and Coppetts Road. The conical topped Edwardian house on the right is on the corner of Kings Avenue, laid out from 1897 by builder J. Pappin. Tetherdown was previously known as Tatterdown.

Coppetts Road winds downhill from Tetherdown, crosses Creighton Avenue, and led once to Coppetts Farm, which survived until the inter-war years. Further on, the road passes the 1888 Isolation Hospital, on the boundary with Friern Barnet, where some unbuilt land remains, close to the North Circular Road. The name on the street gas lamp shows that the photograph was taken on the corner of Greenham Road on Muswell Hill's northern boundary. The houses on the left seem to have been built at the turn of the century, with the trees in front of them obviously older.

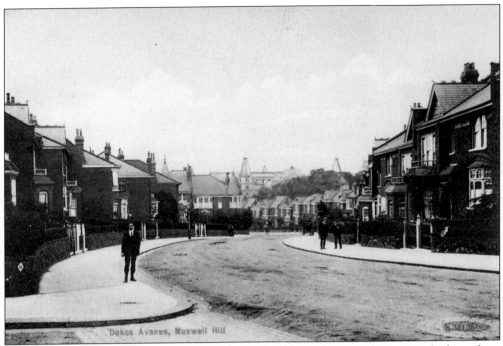

Dukes Avenue and turnings from it, such as Wellfield and Elms Avenue, were laid out from 1900 by Edmondson and lined with substantial terraced houses. Some of this area was once Clerkenwell Detached, but came back under Hornsey's control at the beginning of the century.

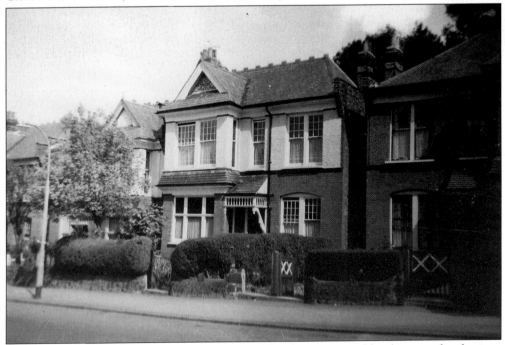

This Dukes Avenue house was built in 1902 and has been occupied by the same family since 1916. The photo was taken in 1965. Note the decorative plaster work, or pargetting, under the eaves, typical of the area.

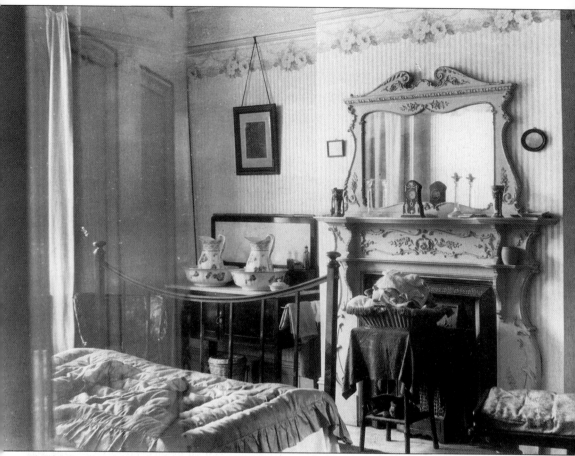

The bedroom of a Dukes Avenue house, photographed in 1921. Note the washstands with basins and ewers, which were in all the bedrooms of the house. The elegant fireplace and overmantel with mirror is an original fitting, and is now a sought-after feature by house purchasers.

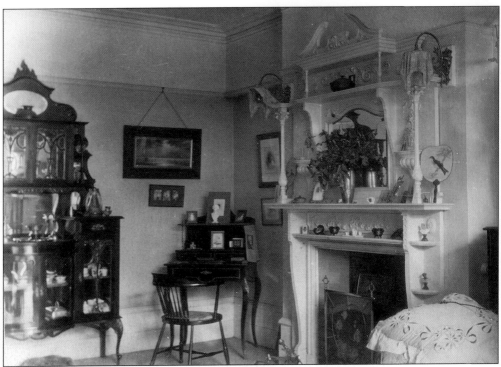

A downstairs reception room in a Dukes Avenue house, photographed in 1921. This room also has an elaborate fireplace and overmantel.

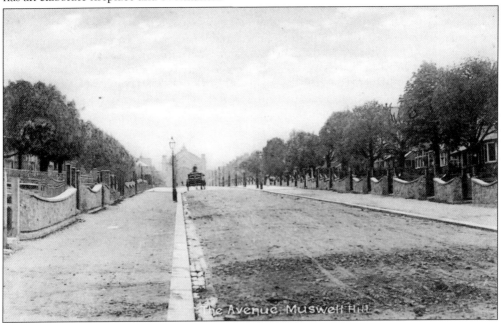

The Avenue, and other roads on the north side of Alexandra Palace, were built up from 1900 onwards. Originally The Avenue was the formal tree-lined route to the palace from the north, crossing empty parkland. The boating lake area at its top (left) was saved from developers in 1900.

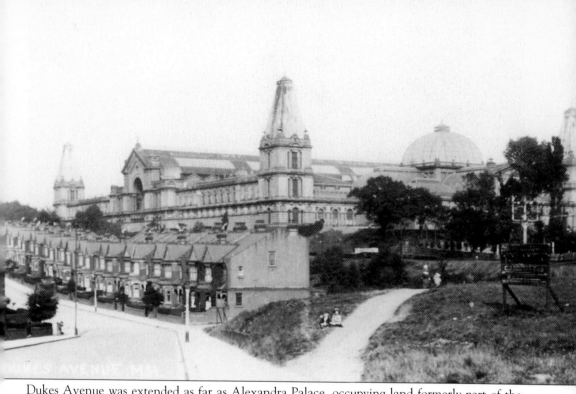

Dukes Avenue was extended as far as Alexandra Palace, occupying land formerly part of the park. The sheer size of the palace as it looms over the houses is revealed in this view. The empty foreground space has been filled with some garages and more houses. The entrance to the park here leads under the railway bridge bringing the branch line to the palace. The entrance would have been used by those wanting to catch a tram. The tram service from the west end of the palace ran downhill out of the park to Priory Road then to Turnpike Lane.

The corner of Dukes Avenue with Grove Avenue. The commodious house shows Edwardian architectural panache as it turns the corner, with its circular bay and conical turret. These features can be seen today elsewhere in Edwardian Muswell Hill. The photograph is dated 1992.

Springfield Avenue shows arts and crafts architectural styles, typical of the 1900s. The avenue is between Alexandra Park and steep Muswell Hill and is built on the site of The Grove, demolished c. 1870.

Eleven

Amenities and
Community Services

Highgate and Queens Woods in Muswell Hill Road have always been favourite places to visit, especially for a weekend stroll. They are a welcome amenity for residents of both Muswell Hill and Highgate.

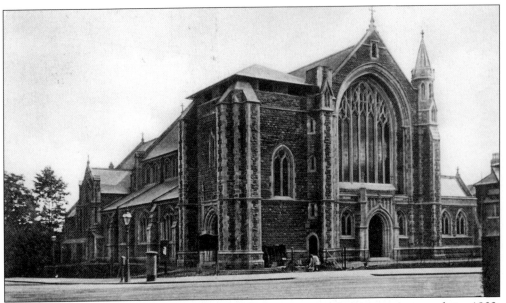

St James's church before the completion of the tower and spire. consecrated in 1902, completion of the new church was delayed by a lack of funds until 1910. Queuing for Sunday services was not unusual, with congregations in 1903 of nearly 700 in the morning and 400 in the evening.

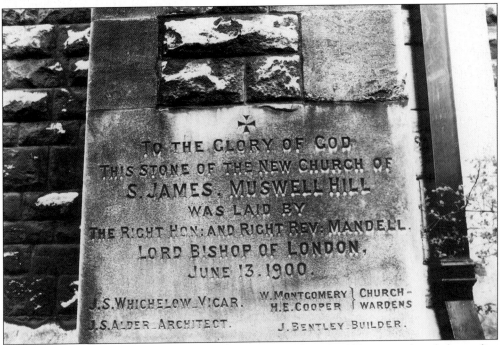

St James's church foundation stone of 1900. Designed by J.S. Alder, it replaced the earlier church on the site which by 1898 was in disrepair and too small. The full name of the Bishop of London was Dr Mandell Creighton. Oops!

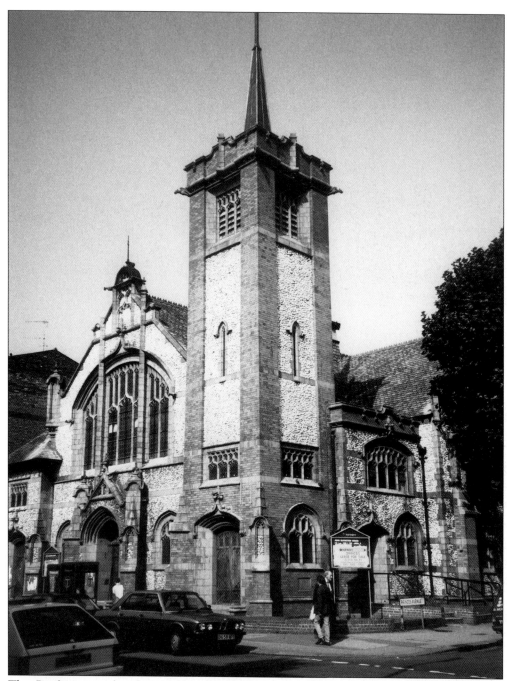

The Presbyterian church in Muswell Hill Broadway with its 1902 foundation stone was designed by George Baines and his son Reginald. Its Art Nouveau Gothic style uses flint, terracotta and hard red Ruabon brick. Reputedly Scottish Presbyterians were prominent in local life and Sunday services numbered nearly 800 in the congregation. Made redundant in 1972 the church was converted in 1997 into a public house. The church hall behind, built in 1898 to designs by Arthur O. Breeds is converted into residential flats.

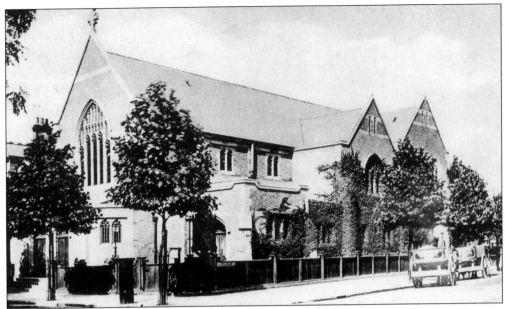

The Congregational church built from 1898 on the corner of Tetherdown and Queens Avenue to the designs of J. Morley Horder on a site given by Edmondson. Sunday service attendances of 600 both morning and evening were achieved. Since 1973 it has become the United Reformed church, absorbing the Presbyterians.

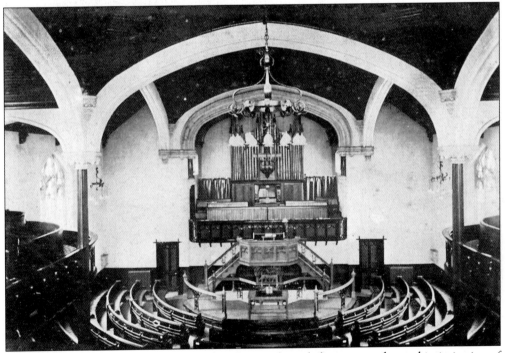

The interior of the Baptist chapel in Dukes Avenue has a balcony curved round in imitation of Queens Hall, London. A revolving fan system in the tower secures perfect ventilation. This fine interior survives today.

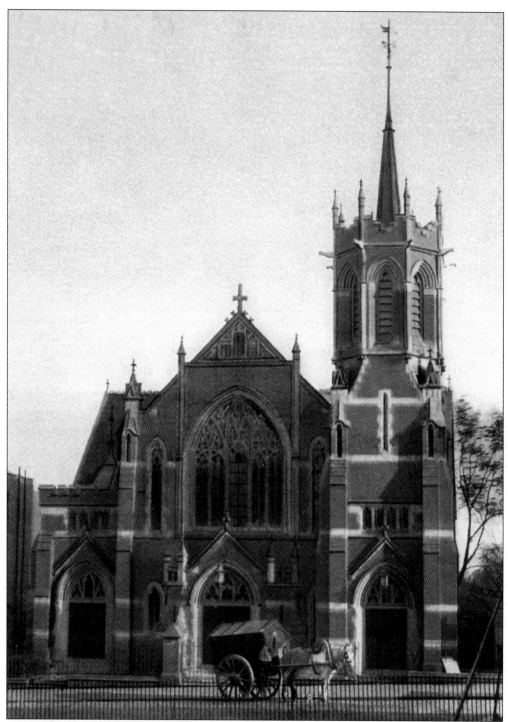

The Baptist chapel was built in Dukes Avenue on a site given by Edmondson. The foundation stone of 1901 was laid by his wife. The architects were George Baines and his son Reginald who also designed the Presbyterian church. It was opened in 1902. The congregations numbered up to 900.

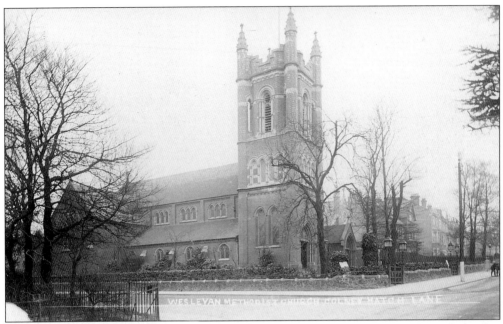

The Wesleyan Methodist church was built 1899-1904 on the corner of Alexandra Park Road to Josiah Gunton's designs. Over 300 attended morning and evening services. The church was demolished in 1982 due to cracks appearing and a new church built at North Bank, Pages Lane on the other side of Colney Hatch Lane.

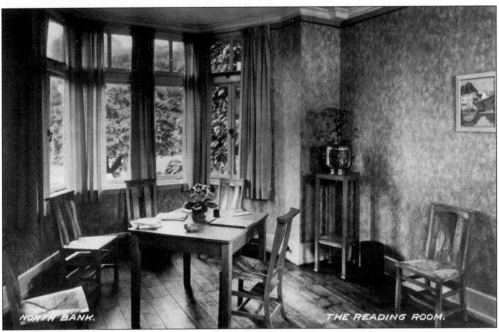

North Bank in Pages Lane served as a Methodist Youth Centre before the Second World War. Still run by the Methodists it is a venue for many activities. A youth hostel and national Methodist youth centre is built nearby.

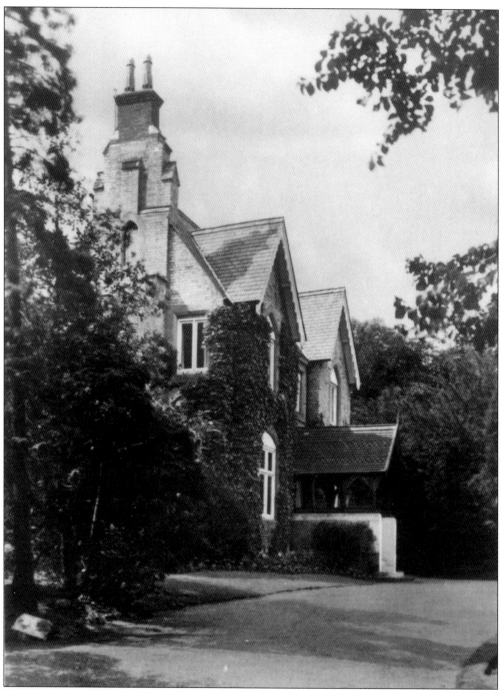

North Bank, a Victorian villa in Pages Lane with extensive grounds was purchased in 1924 by Guy Chester who lived in Hazelhyrst in Colney Hatch Lane. It was altered and re-opened in 1932 for work on behalf of the local Methodist church. Guy Chester also owned Devonshire Lodge on the corner of Pages Lane where a Methodist youth centre was built in 1959. A new Methodist church was constructed on the east side of North Bank in 1985; sheltered housing for the elderly has been built in the grounds.

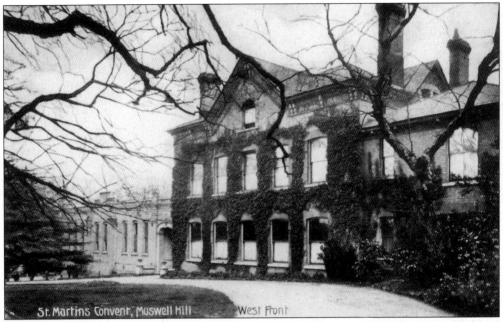

St Martin's Convent moved into Springfield house in Pages Lane in 1907. The convent chapel served the local Roman Catholic community until a temporary church was opened in Colney Hatch Lane in 1920. A school was opened at the convent. In 2000 the convent closed and the building ws sold, but the school next to it survives.

A private junior girls school was run by the nuns in St Martin's Convent in Pages Lane, with additional buildings erected for it in 1909. In 1959 the school became Our Lady of Muswell Hill RC mixed primary, with extended premises.

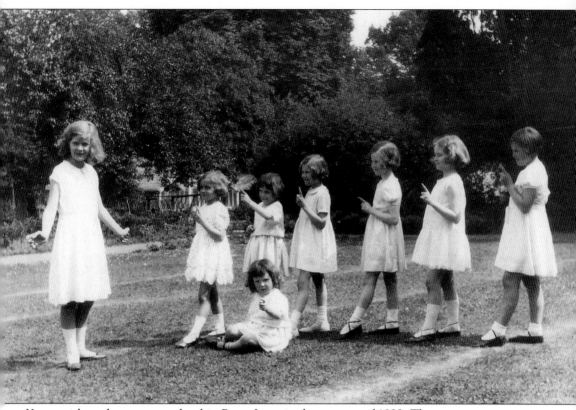

Young girls at the convent school in Pages Lane in the summer of 1933. The convent was run by sisters of St Martin of Tours, founded 1835, who took refuge in a Tetherdown house in 1904 after religious teaching orders had been expelled from France.

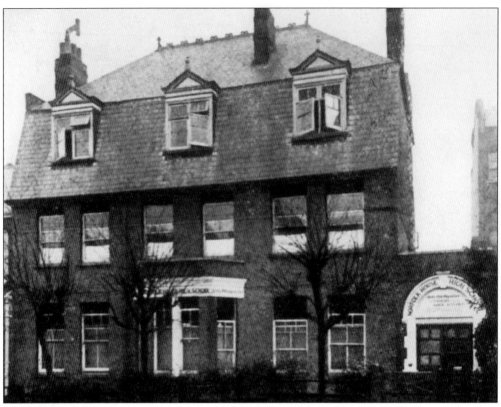

Norfolk House junior school was built in 1897 in Muswell Avenue. By 1908 there were some seventeen other private schools in Muswell Hill but Norfolk House claimed to be the only purpose-built one. It still operated in 2001.

Tollington School was built in 1902 by joint proprietor Mr Campbell Brown in the grounds of his Tetherdown house. The fee-paying boys' school was a branch of Tollington Park College, Islington and had nearly 300 pupils by 1906. Tollington girls' school opened in 1911 in Grand Avenue, later to become Tetherdown primary school. Tollington was absorbed into the Middlesex county education system in 1919. The building is used today by Fortismere Comprehensive School (situated behind it) and for adult education.

Opposite: St James's National School, built 1850 in Fortis Green to designs by Anthony Salvin, seen in May 1963. Extended several times it was demolished in 1969 to reopen in Woodside Avenue. Charles Clore House now stands on its site.

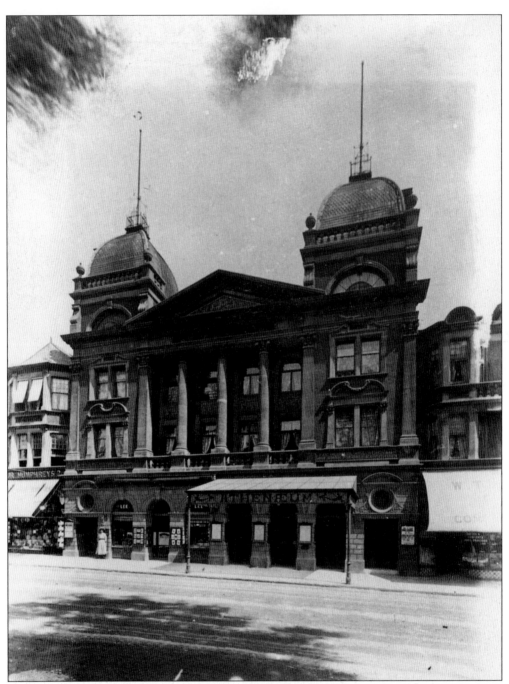

The Athenaeum built from 1900 in Fortis Green Road by Edmondson to provide local facilities for his new suburb. It survived till 1966 when it was replaced by J. Sainsbury. It had two halls seating 466 and 200 and other rooms. These were used at different times by a conservatoire of music, a girls' school (from 1910), a cinema (from 1920) and by the Muswell Hill Parliament, a debating society founded in 1909 which continued for many decades. It was also used by a spiritualist church and for a synagogue. Photographer Arthur W. Lee occupied the shop in front.

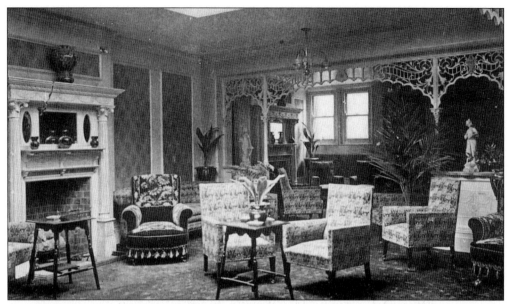

The Athenaeum Lounge Drawing Room was fitted and furnished in this view in a style to be found in many local Edwardian houses. Potted plants were included among the furnishings.

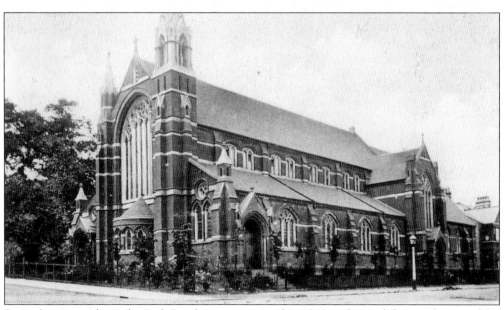

St Andrew's in Alexandra Park Road was consecrated in 1903 and served the new homes of the neighbourhood. Architect J.S. Alder, who had also designed St James's, lived nearby and served as a sidesman. The church has been remodelled after wartime bombing.

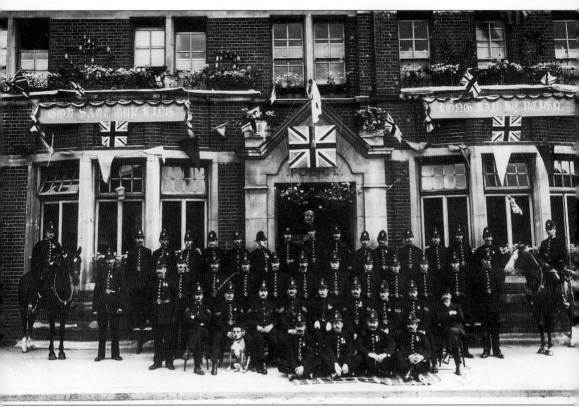

Muswell Hill police force outside their Fortis Green station celebrating King George V's coronation of 22 June 1911. When opened in 1904 the police station was staffed by an Inspector and 11 constables with stabling for six horses. Local needs had previously been catered for by Highgate police station although a pioneering police phone box had been used in Muswell Hill before its police station opened. Local crimes had included the Muswell Hill Outrage, when burglars wounded the householder at Norton Lees in Woodside Avenue in 1889, and the notorious Muswell Hill murder of 1896, when burglars killed a householder in Tetherdown. Muswell Hill police station still operates on a restricted basis.

Twelve
Between the Wars

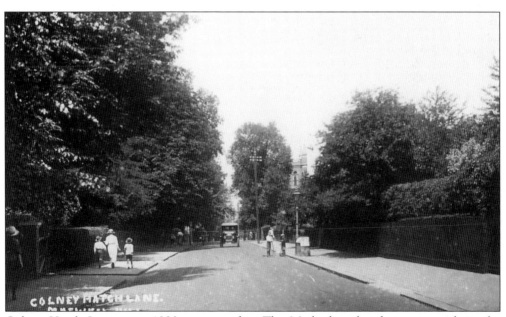

Colney Hatch Lane on a 1920s summer day. The Methodist church tower stands in the distance. Neat hedges line the front gardens and only a solitary car passes. A lad stands with his foot-scooter in the roadway.

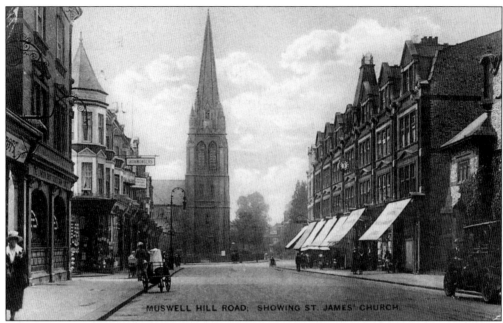

MUSWELL HILL ROAD, SHOWING ST. JAMES' CHURCH.

St James's Church looms over the Broadway, still called Muswell Hill Road. Parked vehicles include one saloon car and a handcart for delivery of milk from a churn. The ironmonger's on the corner of Hillfield Park is Carpenter's. Ivy grows on the Presbyterian Church.

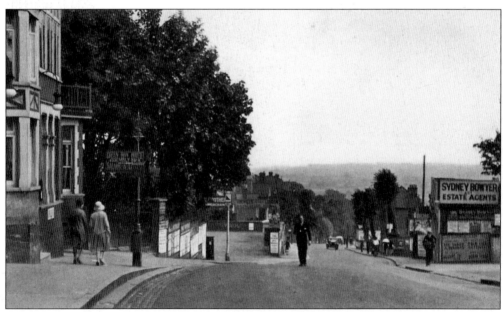

Muswell Hill has no vehicles rushing up and down it in this 1920s view. The railway station still operated below The Green Man (left). Near the estate agents the Ritz cinema was to be built in 1936.

The local British Legion marches through the Broadway. Founded from several ex-service-people's groups in 1921 the British Legion reflected the shadow of the First World War which hung over the 1920s and 1930s, with many bereaved families, Armistice Day parades and the eleven o'clock silence.

Muswell Hill Library in Queens Avenue was designed by the Hornsey Borough Engineer, Mr W.H. Adams, and opened in 1931. In 1994 it was listed Grade II, partly because of the 1937–39 mural frieze by Hornsey School of Art. The site was given by Edmondson for Muswell Hill's first fire station in 1899.

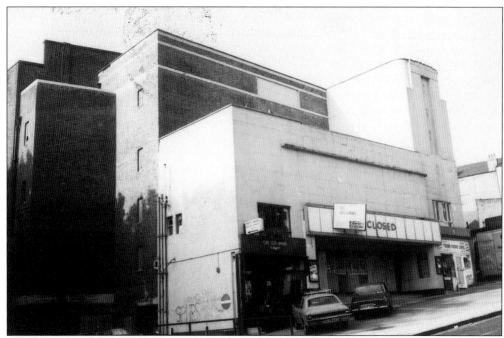

The Ritz cinema, designed by W.R. Glen, opened on Muswell Hill in 1936, three months after the Odeon. In 1962 it became the ABC but it closed in 1978. An office block is now on the site. Another cinema was the Electric Theatre in Summerland Gardens, operating c. 1924–38.

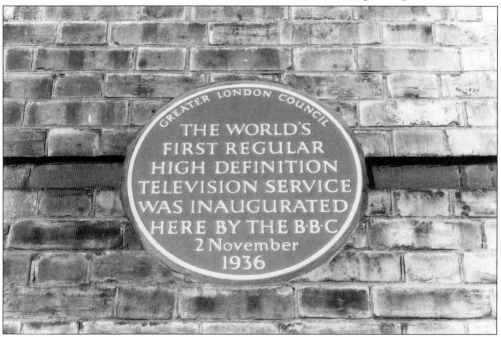

Alexandra Palace's GLC blue plaque records the start of a regular public television service in November 1936, the year that two cinemas were built at Muswell Hill, the Odeon and the Ritz. In February 1937 the BBC chose the Marconi-EMI system in preference to Baird's and became the world pioneer.

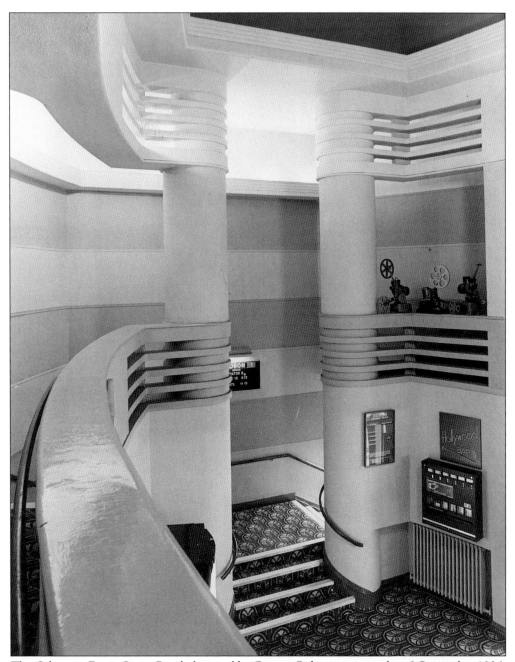

The Odeon in Fortis Green Road, designed by George Coles, was opened on 9 September 1936. Its streamlined art deco interior, photographed here in 1991, helped it to be listed Grade II, despite the 1974 conversion to three screens. The cinema is part of a corner complex which includes shops and flats. St James's successfully opposed original plans to have the cinema entrance directly opposite the church.

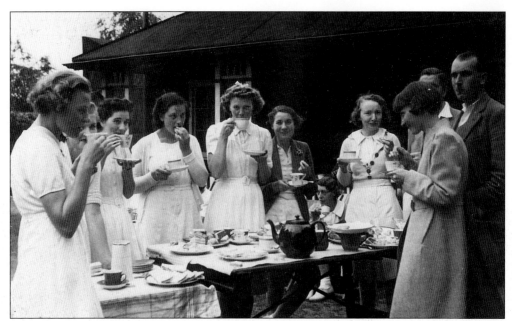

Our Lady of Muswell Lawn Tennis Club takes tea outside the pavilion in 1938. The courts had been laid out in 1910 on the north side of Alexandra Palace and first used by Avenue Lawn Tennis Club. Rhodes Avenue is now the location for the OLOM club. The Alexandra Park site is now a children's playground.

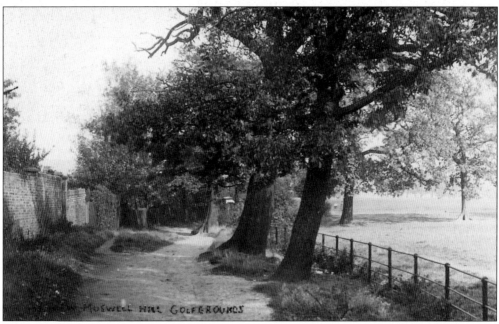

Muswell Hill Golf Club, founded in 1893, acquired land for their course north of Alexandra Palace from the palace and park estate owners, thus providing an additional 'green lung'. Between the wars, membership was about 400 including some 100 women. The centenary was recently celebrated.

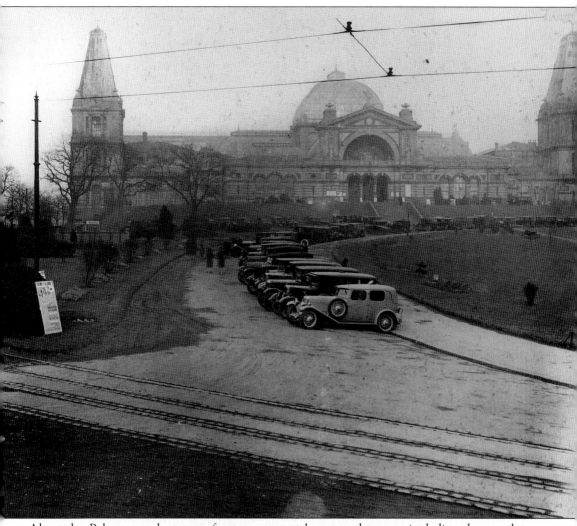

Alexandra Palace was the venue for many events between the wars, including the popular North London exhibition from 1927. These cars appear to be on display on the Palm Court side of the building. Tram lines and wires cross in the foreground. On their grounds within the race track area in the park Alexandra Park Cricket Club continued to play. From 1921, four Saturday elevens were having regular fixtures.

In 1932 a memorial shrine was erected to Father Powell, first rector of the new Catholic parish on a site he purchased in 1917 in Colney Hatch Lane. A parish hall, serving as a temporary church, was built in 1920, a presbytery in 1930 and a church in 1939. During excavations for the presbytery a fourteenth-century statue was found.

Our Lady of Muswell Catholic Church, with its 1938 foundation stone, was opened in March 1939 on the Colney Hatch Lane site. Designed by T.H.B. Scott, it accommodates 600.

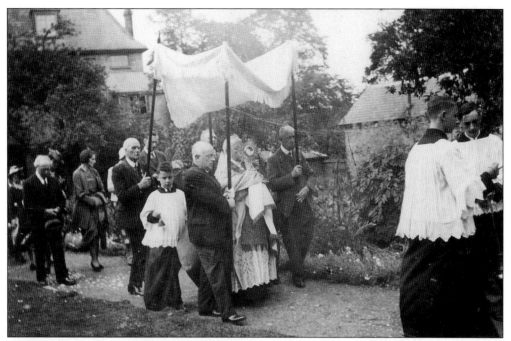

The solemn opening of Our Lady of Muswell church in 1939 by His Eminence Cardinal Hinsley, Archbishop of Westminster. Consecration of the church was to be in September 1959.

The procession enters Our Lady of Muswell Church. It is named after the medieval chapel built on the opposite side of Colney Hatch Lane by the Clerkenwell nuns near the holy well which gave Muswell Hill its name. The chapel was destroyed in the sixteenth century after the dissolution of religious houses.

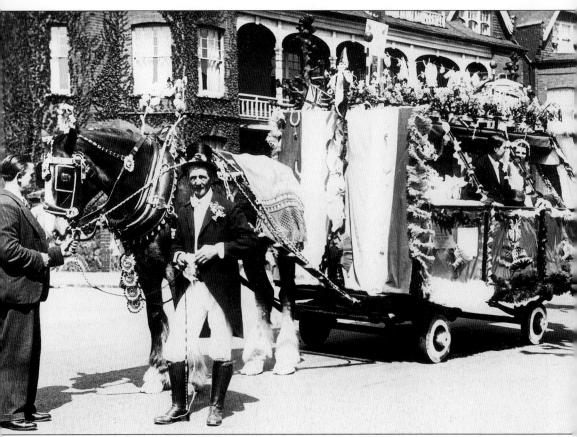

A Silver Jubilee float in Queens Avenue in 1935. National celebrations were held to mark the 25 years of King George V's reign. The King died the following year. In the 1930s, horse transport was still common for deliveries of all kinds and horse-drawn vehicles were available for processions. Milk and coal and other heavy goods were still being delivered by horses in the 1960s.

Thirteen

Wartime and Post-War Years

An incendiary bomb, photographed on 20 April 1941 in Grand Avenue. St James's church had been burnt out by a fire bomb on 19 April. High explosive, incendiary and phosphorous bombs fell from 1940. On 16 June 1944 Hornsey's first V1 flying bomb landed in Cranmore Way. Two were killed and 16 injured by a V1 in Fortis Green on 26 July 1944. A V2 devastated Etheldene Avenue on 3 January 1945, killing three and injuring twenty seven.

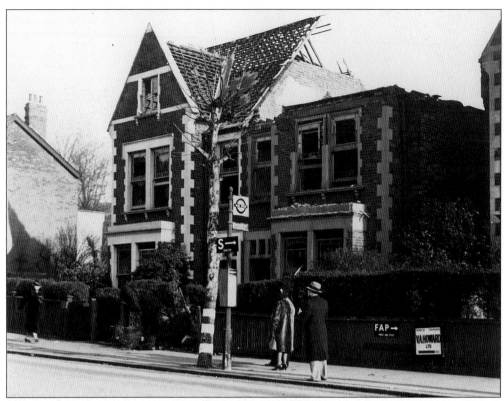

The premises of R.W. May, dentists, at 166 Muswell Hill Road, on 8 December 1940 after bomb damage. The FAP sign indicates a First Aid Post and the 'S' sign on the bus stop points to a shelter.

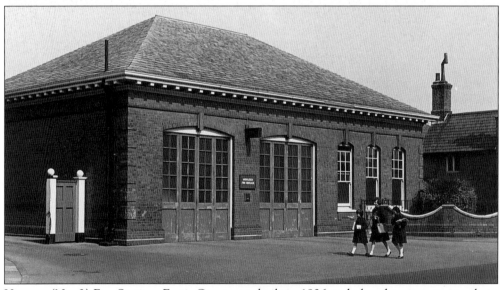

Hornsey (No. 2) Fire Station, Fortis Green, was built in 1926 and played an important role in the Second World War. It was replaced from 1963 by the new Priory Road fire station. The site opposite Leaside Mansions is now used by a medical clinic, formally opened in November 1965.

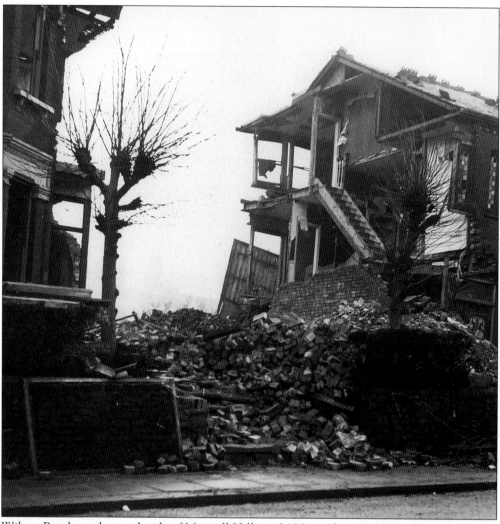

Wilton Road, on the north side of Muswell Hill, on 24 November 1940. The houses had been destroyed by a land mine – high explosive delivered by parachute by enemy planes. Wilton Road connects Colney Hatch Lane and Coppetts Road and is just within Barnet. Casualties suffered by the Borough of Hornsey between 1940 and 1945 included 214 civilians killed and about 1,290 injured. Over 80 per cent of the housing stock was damaged or destroyed.

The rear of 65 Grand Avenue photographed on 11 May 1941, the morning after an air raid. The back bedroom window has been blown in by the force of the bomb blast, which also tore off roof tiles. A high explosive bomb had fallen in Collingwood Avenue.

Grand Avenue on Christmas Day, 1945. Two Chinese paratroopers from Vancouver just back from India are welcomed in. The shed on the right in the background is still standing, adjacent to Tetherdown School.

It is August 1947 and time to get the car out again now that the war is over, despite the continuance of petrol rationing. It stands ready in Grand Avenue.

The corner of Tetherdown and Pages Lane in February 1964. More and more cars were coming out onto the roads. But the traffic island had not yet been installed here. The corner shop which had long been an off-licence was later to be occupied by the British Darts Organisation and Broadways was to become Crofts Tiles.

Chester House was built 1959–60 on the corner of Colney Hatch Lane and Pages Lane on the site of Devonshire Lodge, owned by underwriter Guy Chester. Chester helped finance the building of this national Methodist youth centre and hostel.

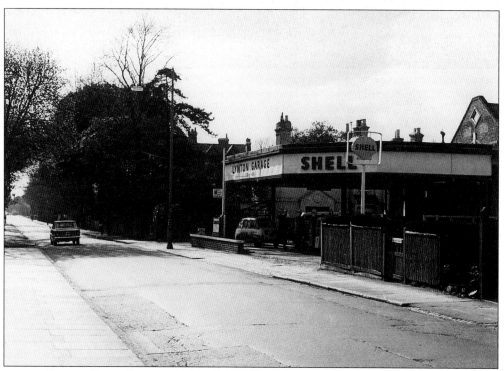

Lynton Garage, Fortis Green, in May 1963. The site opposite Eastern Road and adjacent to Lynton Grange (rebuilt as a block of flats) has been used for garages since at least 1924.

Muswell Hill Broadway, near the roundabout, in the Colney Hatch Lane section, photographed in June 1963. Northern House was a well-used local department store with a wide range of household goods. Its premises stretched extensively to the rear, and there was another shop entrance round the corner. The entrance shown is currently occupied by an insurance firm. Tesco supermarket (left) is now a restaurant.

Opposite: Surviving in the Broadway are the upper storeys at least of two Victorian houses. When photographed in 1979 the ground floor shops were occupied by a florist and a charity shop. They have since been absorbed into a branch of Marks and Spencer.

Queens Parade on Good Friday, April 1963. United Dairies on the corner of Queens Avenue is now a branch of 7-Up. Burton Tailoring is now Nationwide. Pedestrian crossings have been installed here.

Roller skaters at Alexandra Palace in the early 1960s. The rink had been consistently popular since Edwardian times, and kept open during the Second World War. Closure in the 1970s was due to structural problems. Ice skating has replaced roller skating at the palace, a new rink opening in July 1990.

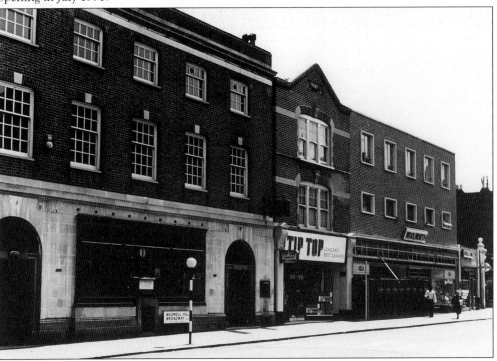

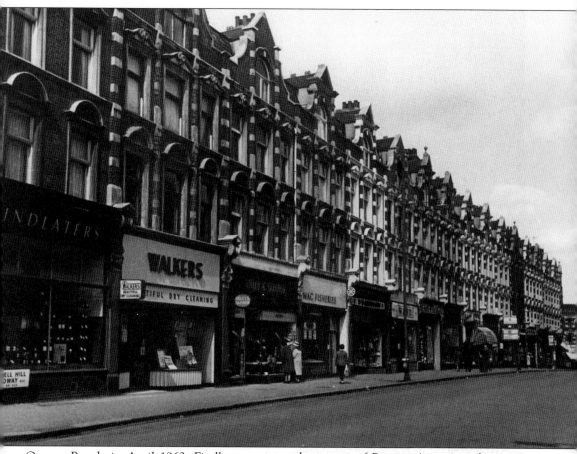

Queens Parade in April 1963. Findlaters was on the corner of Princes Avenue and is now another off-licence. W.H. Smith remains in the same shop. Further on is Martyn's. Shop occupiers have changed considerably over the years, with one or two notable exceptions.

Opposite: The General Post Office and Woolworths in the Broadway, in the Colney Hatch Lane section, in June 1963. The branch of Woolworth's was being enlarged at that time. The 1936 date-stone and GVR cypher on the post office have been covered over in the 1990s.

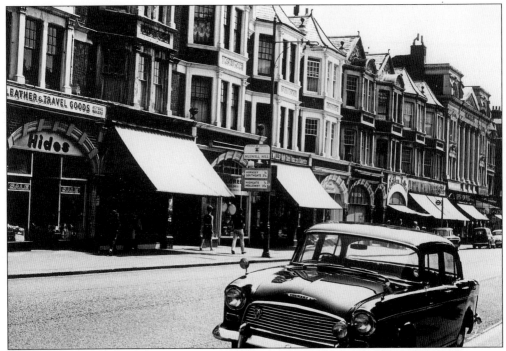

Fortis Green Road in June 1963. The Athenaeum, destined to be demolished three years later, is still to be seen. Canvas awnings remain in use by some of the shops, pulled out over the fine, curved window fronts. There is a pleasant scarcity of cars. But the Humber in the foreground, and three parked cars, are forerunners of the overwhelming tide of traffic that will change life in Muswell Hill over the next decades.

Acknowledgements

Permission to reproduce copyright material has been granted. The relevant page numbers are given.
British Library, 85
British Museum Department of Prints and Drawings, 15, 20 (top), 22 (bottom), 25, 47 (bottom), 64 (top)
Bruce Castle Museum, London Borough of Haringey, 72 (top)
Greater London Record Office, 59 (bottom), 68 (top)
Highgate Literary & Scientific Institution, 10 (bottom), 11 (bottom), 14 (top), 20 (bottom), 21, 22 (top), 23 (bottom), 24 (bottom), 26 (top), 27, 29 (both), 36 (bottom), 37 (both), 38, 39 (top), 41, 42 (top), 43, 44 (bottom), 47 (top), 48, 50, 56 (bottom), 57, 58, 59 (top), 60 (top), 62 (bottom), 63, 64 (bottom), 65 (bottom), 67 (top), 73, 76 (both), 77 (both), 82 (both)
Royal Commission on the Historical Monuments of England (Crown Copyright), 46, 51 (bottom), 69 (bottom)
Sharon Smelser, 32
Theatre Museum, London WC2, 60 (bottom)

Index